LEGENDARY

OF

BAY CITY
MICHIGAN

M000206443

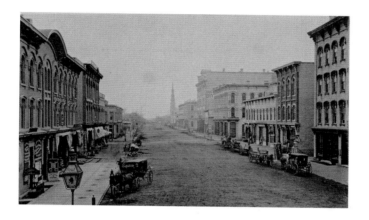

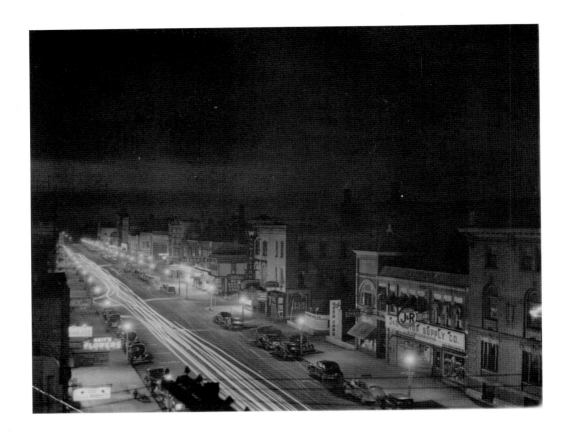

Page 1: Bay City, c. 1877

This photograph of Bay City was taken during the heyday of lumbering, c. 1877, looking east on Center Avenue from about Saginaw Street. The Shearer Block (later Mill End) is partially seen on the left and the Heumann Block (Chas. Brunner, Grocer) later housed the famous Caris Red Lion restaurant for many years. On the right, the tall building was the Westover Opera House where the Phoenix Building now stands at Center and Washington, and the distinctive spire of the First Baptist Church (Center and Madison—later razed) can be seen in the distance. (Courtesy of the Bay County Historical Society.)

Page 2: Bay City, 1942

Downtown Bay City's Washington Avenue is seen in this evening photograph from 1942. Looking northeast, landmarks like the Washington Theatre, Keit's Flowers, Tierney's building, Knepps' Department Store, and the Regent Theater in the Davidson Building can be seen along what was once the bustling center of business in Bay City.

LEGENDARY LOCALS

OF

BAY CITY

MICHIGAN

RON BLOOMFIELD

LEGENDARY
LOCALS

Published by Legendary Locals, an imprint of Arcadia Publishing
Charleston, South Carolina

Printed in the United States of America

Library of Congress Control Number: 2012930627

For all general information, please contact Arcadia Publishing:
Telephone 843-853-2070
Fax 843-853-0044
E-mail sales@arcadiapublishing.com
For customer service and orders:
Toll-Free 1-888-313-2665

Visit us on the Internet at www.arcadiapublishing.com

Dedication

To the memory of Leo Najar and Jerry Marcet, Legendary Locals I was honored to call "colleague, mentor, friend . . ."

On the Cover: From left to right:
(TOP ROW) Lionell (Nello) DeRemer, musician/aviator (Bay County Historical Society (BCHS) Archives; page 86–87), Leo Najar, orchestra director (Courtesy of Andrew Rogers; page 94–95), May Stocking Knaggs, suffragette (BCHS; page 108), Oscar Baker Sr., lawyer (Courtesy of Joy Baker; page 38), Juanita Isaac, nurse (BCHS; page 120).
(MIDDLE ROW) Richard DeMara, iron worker/National Guard (Courtesy of the DeMara family; page 110), John C. Weadock, lawyer (BCHS; page 41), Donald J. Carlyon, college president (BCHS; page 116), Albert Logan, sailor (BCHS; page 57), Marian Flora Spore Bush, dentist/artist (BCHS; page 119).
(BOTTOM ROW) West Bay City Active Company, firemen (BCHS; page 30–31), Julia Tobey Brawn Way, lighthouse keeper (BCHS; page 14), Alex Izykowski, Olympic speed skater (Courtesy of Jerry Search; page 101), Annie Edson Taylor, daredevil (BCHS; page 88), Augustus Gansser, soldier/historian (BCHS; page 58–59).

CONTENTS

ACKNOWLEDGMENTS

The original list of names considered for inclusion in this work was around 500, no doubt enough for several volumes. A few things helped narrow that list down, foremost being that those represented must be a cross-section of everything Bay City, which still generates a large list in itself. Another factor was the availability of good quality images to represent those on the list. The majority of photographs included herein came from the extensive collections of the Bay County Historical Society (BCHS), founded in 1919 and well represented in this volume; all of the unattributed photos in this work are from that collection. For those on the list for whom we did not have a suitable photograph, I sought out images that could be used from other sources. I am indebted to the following for providing me with images (and information): Andrew Rogers, Joy Baker, Mike Rowley, Gary (Dr. J) Johnson, the Burdons, Dan Tomczak, Guy and Nancy Greve, Terry McDermott, Jerry Search, Dr. Doug Sharp, the DeMara family/Chris and Pete Vanderwill, Eric Jylha, and the Library of Congress.

A third deciding factor was the availability of good research material to help tell each Legendary Local's story. Again, the Bay County Historical Society's research archives became the primary source, with books, files, and other materials on most everyone included herein. To help round out that research, I am indebted to the following for their help providing materials, insight, and a few solicited quotes about these legendary people: Dr. Eric Maillette, Mike Bacigalupo, Leeds Bird, Tim Younkman, Pam Taber, Ric Mixter, Speed Skating Hall of Fame, Maureen McDermott, Patricia Drury, Linda Heemstra, Bette Jylha, Terry Kelly, Corrine Bloomfield, Emily Kukulis, Diane Wagar, the *Bay City Times*, Bay County Public Library (Wirt) Reference Department, and fellow Arcadia author Leon Katzinger.

I would also like to thank Arcadia Publishing's Tiffany Frary for her guidance through the creation of this work.

Finally, I would like to thank my wife Corrine and my children for their patience through yet another book-building "process."

Historically,
Ron Bloomfield

INTRODUCTION

Bay City, situated at the point where the "thumb" meets the "mitt" of Michigan, is a small city of about 34,000 residents, enough to place it in the middle of the top 100 cities in the state. However, there is quite a population gap when one compares this small city with a Detroit, Chicago, or even New York. One would expect to find droves of Legendary Locals in a large city, and a relatively small amount in a place the size of Bay City; however, throughout our history there have been many Bay City residents who have had an impact globally, not just one or two (which would be expected), but many times over, literally from the depths of the ocean to the clouds, to the farthest reaches of the globe: Australia to Alaska; Panama to England; Near East, Far East, everywhere in between and beyond. Many of our local legends have been involved in the very events that make up the textbooks of modern American history, from the fur trade to world wars, the Great Depression, and a host of other important trends, processes, products, fashions, and philosophies. Could it be that with access to the Great Lakes (and thus access to the world's waterways) literally running down the middle of the city, residents found it easier to focus on a broader vision, or was it some other siren-song calling those destined to greatness to the city by the bay?

Even from the earliest days of Bay City, its residents were never really considered to be average. The earliest pioneers had to endure many hardships to finally establish a small fledgling settlement along the banks near the mouth of the Saginaw River. The earliest residents of "Lower Saginaw" (as Bay City was known in the 1830s) learned early to adapt to living in an area that was swampy, infested with mosquitoes, and prone to harsh winters and hungry wolves. In addition, they had to learn to live in harmony with the local Native Americans who had called the area home for many centuries. Joseph and Mader Trombley, considered to be the earliest permanent residents, helped pave the way for future settlers like the McCormick family, including William R. who would go on to record much of our early history and the history and folklore of the local Chippewa whom he called friends. Chief David Shoppenagons was among the last of his kind, bridging the gap between the traditional way of native life and a life of integration. Other early settlers of note would include James G. Birney (II), one of the founders of the town of Lower Saginaw and twice candidate for president of the United States on the Liberty ticket, James Fraser, and Judge Albert Miller, all highly regarded pioneers.

The lumbering business consumed Bay City during the latter half of the 19th century, when it was considered to be one of the largest lumber producers and exporters in the State of Michigan. Many people, both famous and infamous, were involved in one part of the lumber trade or another. Henry W. Sage and John McGraw were absentee lumber barons, who at one time reputedly owned the largest lumber mill in the world, at Wenona (later a part of Bay City). Fabian Joe Fournier was one of the notorious figures of the era. A lumberjack by trade, he was known as a relentless brawler and was possibly one of the models for the legendary Paul Bunyan stories. Other figures of the lumber era include local entrepreneurs like Capt. Benjamin Boutell who made a fortune towing logs to the mills of Bay City, and other area residents of note who made their living on one part of the trade or another. Also during this time, shipbuilders like James Davidson started the first era of shipbuilding, bolstering the Great Lakes lumber and commodity trade by building some of the largest, fastest, longest, and most profitable vessels on the lakes, one of two yards considered "world-class" by their peers.

It was during this heyday of lumbering that what would eventually become the Bay City of today started out as five distinct villages, each with its own identity. On the east side of the Saginaw River,

Lower Saginaw was incorporated as Bay City in 1859 and Portsmouth, adjoining on the south, was folded into Bay City in 1865. On the west side of the river, Banks (1853), Wenona (1864), and Salzburg (1862) all combined to form West Bay City in 1877. During the latter half of the lumbering era, both Bay City and West Bay City were considered giants among lumber producers in the Midwest, if not the nation. Unfortunately, by the late 1890s, that all would change. . . .

In the late 1890s, the timber that was used as the raw material to make finished lumber started to run out. Advances in technology sped up production to a feverish pitch and what was once thought to be an almost inexhaustible supply of trees soon vanished. So did the lumbering operations that either abruptly left or simply ceased to exist. That void left Bay City and West Bay City in a serious state of affairs. The consolidation of both towns into "Greater Bay City" was legislated in 1903 and accomplished in 1905, ushering in a new era of prosperity as a search for a new industry that would drive the economy began. A host of Bay City entrepreneurs stepped up to fill the incredible void left by the abrupt departure of the lumber industry. Otto and William Sovereign made millions of dollars selling pre-cut housing, launching an industry that would come to define an entire era of consumerism in America. Harry J. Defoe started the Defoe Shipbuilding company, which would later become one of the best-known shipbuilders on the lakes and build warships, pleasure craft, and even a yacht that served three US presidents. It was also within this decade that William L. Clements would help transform the Industrial Works into a major national force in railroad crane production.

A return to the glories of the lumbering era is most likely never going to happen, but Bay City's business and cultural diversity, and with it entrepreneurs who also aspire to leadership within the community, has allowed for individuals to stand out as legendary among their peers in the city they call home. From the earliest to the most recent, the list is diverse and includes sports figures like world class Olympians Alex Izykowski, Doug Sharp, and Terry McDermott; notable women like suffragist May Stocking Knaggs, who was an acquaintance of Susan B. Anthony; and Bay City's first woman mayor Anne Hachtel. The list also includes cultural and entertainment icons who helped give the city a sense of identity, including Maestro Leo M. Najar, a world-class composer, conductor, and founder of the Bijou Orchestra; Harry Jarkey of Wenona Beach; and Lionell (Nello) DeRemer from WBCM. Many other inventors, advocates, developers, artists, sports figures, musicians, actors, and playwrights can be proud to share the title of Legendary Local; their names can still be found on Bay City's streets, businesses, buildings, and in local cemeteries and family pedigrees that include multiple generations.

CHAPTER ONE

Founding the Lumber Town

Our Work is done. It was a humble work. The Pioneer's name never shines among the brilliant and illustrious names on the historic page. He is only a pathfinder, carrying the torch of discovery into the wilderness; yet without him civilization is impossible. Those busy manufactories that to day line the Saginaw River; those beautiful church edifices that crown our prosperous towns; those magnificent school buildings, that stand as the proudest and best monuments of modern civilization—these are all the fruits of our Work into which other men have entered.
—William R. McCormick, 1874

The natural resources were already there; all it took was for some enterprising pioneers to find a way to take advantage. The original settlers came to the area to trade with the native Ojibwe, and ultimately found resources available with which to make a living. The Trombley and McCormick families became part of the earliest fabric of Lower Saginaw. It took visionaries like Albert Miller, James Fraser, and James G. Birney to envision a town that was more than just a mere settlement in the wilderness. Perseverance paid off when early settlers like James Shearer officially made the town their home. Navigation aid was something much needed by the emerging port town and the Brawn family played a great role in keeping the lights lit. Locals soon discovered that money could be made by processing, shipping, and selling lumber and lumber products and that Bay City was situated in the perfect path to reach that market. Henry Sage and John McGraw, both absentee lumbermen, exploited the natural resources with large mill operations that employed many in the bustling town. S.O. Fisher, J.R. Hall, Mendel Bialy, A.E. Bousfield, and the Eddy Brothers were among other lumbermen who made their fortunes in Bay City. Capt. Nate Murphy was as "tough as they come" in a young police force whose job was to keep the lumber town in check from brawlers like Joe Fournier who used the town's establishments to let off a little steam. The Active Company of the West Bay City fire department was one of an emerging group of heroes in a city built of wood.

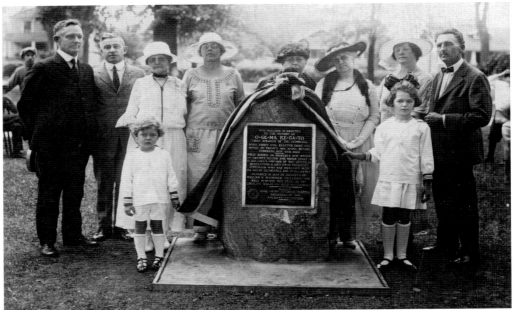

O-GE-MA KE-GA-TO Memorial Dedication

This memorial stone was placed in Roosevelt Park in 1923 by the Anne Frisby Fitzhugh chapter of the Daughters of the American Revolution to honor the burial place of Chief Ogemaw (c. 1794–1840), who was "Chief Speaker of the Chippewas" at the 1819 Treaty of Saginaw and spoke before Congress in 1837. He was buried in a colonel's uniform of the American Revolution, which had been a gift from President Jefferson, who was impressed by his great eloquence and intelligence. The treaty of 1819 paved the way for Bay City's development.

Chief David Shoppenagons

Though his official home was north in Grayling, Chief Shoppenagons was very much considered a part of Bay City's history. He was a descendant of Ojibwe (Chippewa) chiefs and held the title of "Chief" until his death (likely in his 90s) in 1911. He was well known and respected among many in Bay City, and Shoppenagon Grotto, a Masonic-based organization based in Bay City, was named in his honor.

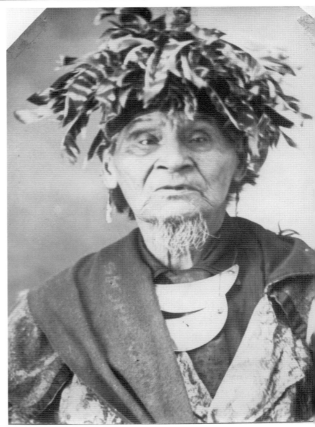

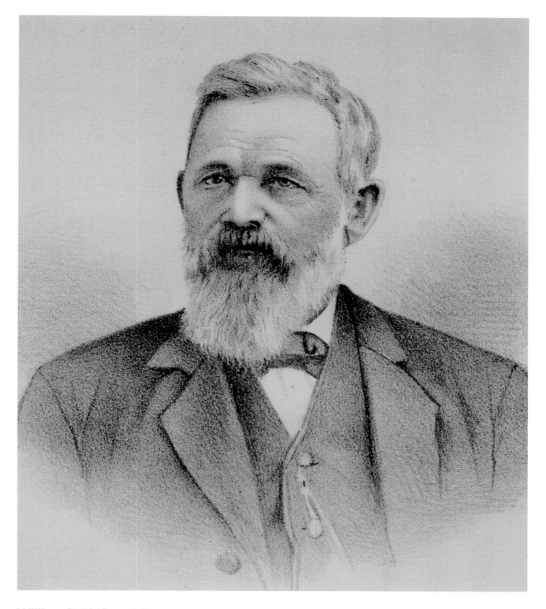

William R. McCormick

McCormick (1822–1893) was one of Bay City's earliest historians. When he was a child, his father James moved the family to a very sparsely settled Lower Saginaw. In 1841, his father purchased the Portsmouth Steam Mill, the second sawmill in the area, and reportedly shipped the first load of lumber out of the Saginaw River soon thereafter. A few years later, his family purchased the Trombley brothers' house and turned it into a boardinghouse called the Centre House. William McCormick quickly befriended Native Americans who were living in the area and chronicled their oral tradition, creating an early written record of events like the Battle of Skull Island. McCormick also penned many "historical sketches" of local pioneers, which he preserved in his memoirs, which were subsequently donated by his heirs to the Bay County Historical Society in the 1920s.

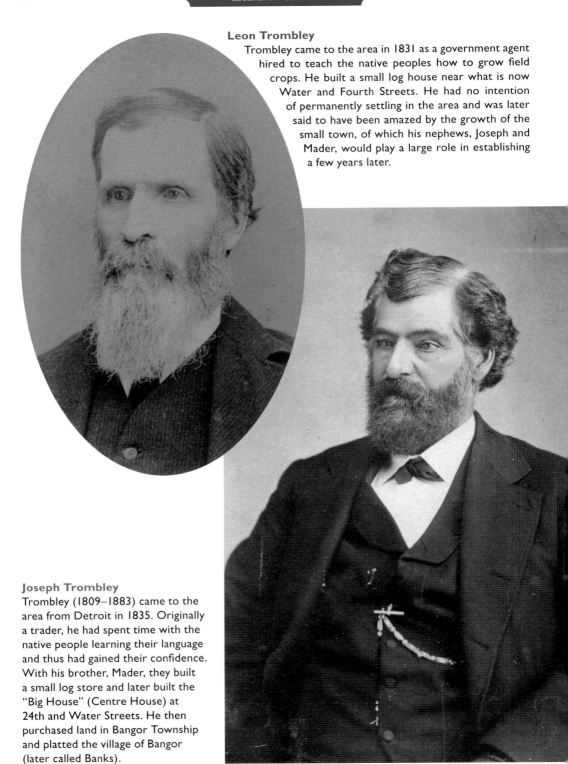

Leon Trombley

Trombley came to the area in 1831 as a government agent hired to teach the native peoples how to grow field crops. He built a small log house near what is now Water and Fourth Streets. He had no intention of permanently settling in the area and was later said to have been amazed by the growth of the small town, of which his nephews, Joseph and Mader, would play a large role in establishing a few years later.

Joseph Trombley

Trombley (1809–1883) came to the area from Detroit in 1835. Originally a trader, he had spent time with the native people learning their language and thus had gained their confidence. With his brother, Mader, they built a small log store and later built the "Big House" (Centre House) at 24th and Water Streets. He then purchased land in Bangor Township and platted the village of Bangor (later called Banks).

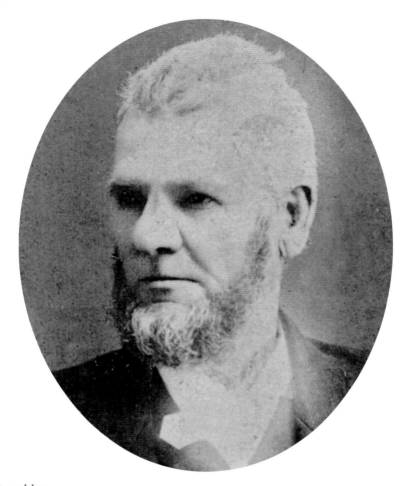

Mader Trombley

Trombley married Sarah McCormick, sister of William McCormick and daughter of James and Ellen McCormick, in 1847. The two had met years earlier near Flint. Some years later, she wrote about her husband and the early years in Lower Saginaw. "There came a young man from Lower Saginaw with moccasins on his feet, and dressed in the garb of a frontiersman; he was tall and athletic, and he received a large amount of silver from the Indians in payment for goods which they purchased from him, and for the want of anything better he carried it in a woolen sock. He seemed to have more than some of the other boys, and in a friendly way they tried to get it away from him, and as he danced around the floor with the silver in his hand, I said to Mother, although I was only eight years old, 'I'm going to marry that man.' In 1841 we all moved down to Lower Saginaw and my Father purchased what was then known as the big house, later known as the Center House, the first frame building in Lower Saginaw, and it was here that I again met my hero of childhood fancy. In 1847 we were married and moved to the home which he had built along the banks of the Saginaw, at what is now Thirty-Fourth Street. This home was furnished complete in every detail with the first mahogany furniture that came to Lower Saginaw, these furnishings were all [brought] by sailboat from Cleveland, the boats coming to the Saginaw Valley but once or twice a year. Our wedding trip was a novel one, although my husband, Mader Tromble, had other means of conveyance, our wedding trip from the Center House to our new home was behind an Ox-team, bumping over the logs and brush, and you can be sure it was a happy and jolly wedding party. Upon arriving at our new home I found it very complete, and most acceptable to the new bride."

Julia Tobey Brawn Way and Peter Brawn

The approach to the Saginaw River was treacherous, and the lighthouse, first built in 1841 and rebuilt in 1876, was a necessity to vessels entering the bustling lumber port. The work of a lighthouse keeper was considered a man's vocation during the 19th century. Contrary to the norm, Julia Tobey Brawn Way (1816–1889) managed the Saginaw River Lighthouses, first working with her husband Peter Brawn from 1866 until his death in 1873, then by herself from 1873 to 1877, and then with second husband George Way until his death in 1883. Both husbands were in ill health much of the time, which necessitated Mrs. Brawn Way handle the duties by herself or with the help of her six children, including son Dewitt C. Brawn. A well-respected member of the community, Brawn Way was eulogized in a newspaper of the time as "a lady who possessed noble traits of character. Being ever ready to aid the distressed and care for the needy. As she lived, so she died, a loving wife, a kind mother and Christian woman."

Dewitt Clinton Brawn

Brawn (1851–1931) was only 12 years old when his father was appointed keeper of the lighthouse at the mouth of the Saginaw River and the family moved to Bay City from Port Rowan, Ontario, Canada. Since his father was crippled, the whole family assisted with the daily operations of the lighthouse. Each morning from his bed in the tower of the lighthouse, he could see freighters at anchor, compelled to wait until morning in order to be assured of safe passage through the channel. Bay City was a busy lumber port during these years. The loss of time waiting at the mouth was expensive and Brawn came upon the idea of erecting range lights to help matters. He erected two towers in a line, the front one being lower, to which he attached a pulley and a line. Every evening he would place lanterns on the towers to guide ships into the river. No matter how dark or stormy the night, the lights could be seen for four or five miles out into the bay. The mariner could see two lights. If one was not above the other and directly in line, the wheelsman would swing the craft over until one light was exactly in line with the other. Keeping those lights in line, the channel could be entered as easily as in daylight. The idea was supported financially by subscriptions from the many ship captains who relied on the system for safe passage. In 1876, the Saginaw River Lighthouse was rebuilt into a fixed-lamp range light, adding a "front" beacon near the mouth of the river. This offered a permanent solution to the problem of navigating the Saginaw River. Brawn remained actively identified with shipping throughout his life. He worked for a few years in the tug office of W.H. Sharp and in 1897 took the position of deputy clerk of customs for the port of Bay City. His service with the US Customs Office gained him the friendship of practically every captain and boatman entering the Saginaw River. During his more than a quarter century of government service, the duties collected through his office amounted to well over a million dollars.

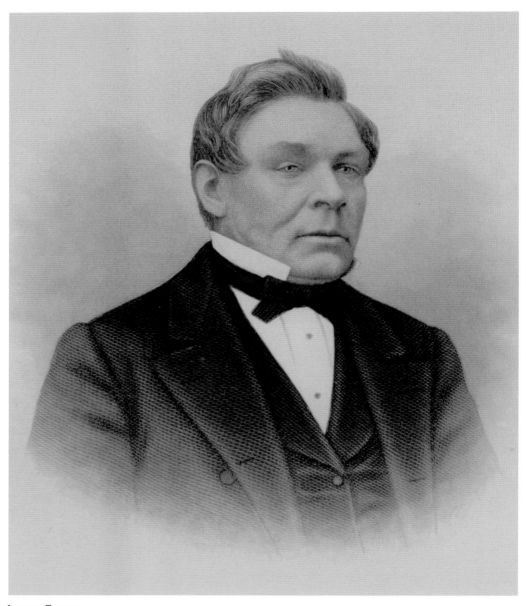

James Fraser

Mr. Fraser's Saginaw Bay Land Company purchased the Riley Reserve in 1836 with the intention of creating a town. Fraser (1803–1866), originally from Scotland, surveyed the property and laid out the village of Lower Saginaw in 1837. A few buildings were built in an effort to stimulate sales; unfortunately several factors including the financial panic of 1837 necessitated the tabling of any future plans until 1843 when Fraser restructured the company with the backing of James G. Birney and Daniel Fitzhugh. This new town would later become the nucleus of what is now downtown Bay City. In 1865, Fraser built the Fraser House hotel on the corner of Center and Water Street, though he did not live to see it completed. It was a fitting memorial to a man highly regarded by many and was the hub of Bay City business and culture until it burned in 1906.

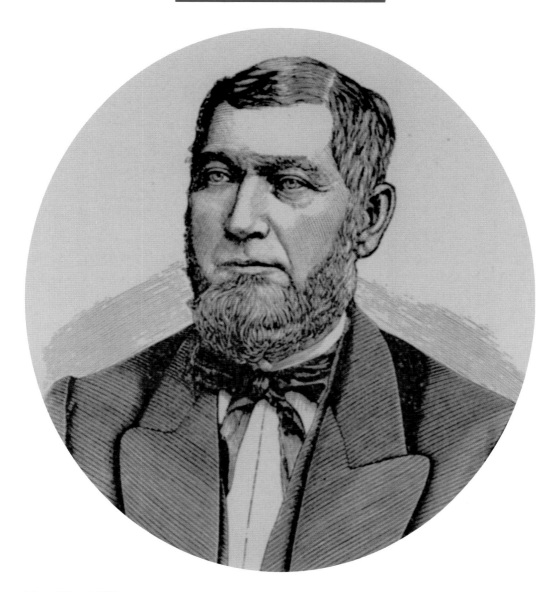

Hon. Albert Miller

Judge Miller (1810–1893) had many pursuits during his life that endeared him as one of Bay City's true pioneers. He moved to Saginaw in 1832 where he taught at the first school in the area. In 1835, he was appointed judge of probate, an office he held for nine years. He was also a justice of the peace (13 years), was elected to the early State Legislature, and was the first postmaster of Portsmouth (now part of South Bay City), a town he developed from land he purchased in 1838 and where he later moved. He built the second sawmill on the Saginaw River, was in the lumber business for many years, and assisted with the building of the first railroad in the area. His attempt at retirement did not last long as he later drained 700 acres of prairie marsh and created one of the finest farms in the area. In addition, he raised a family with wife Mary (Daglish), served over 20 years as an elder in the Presbyterian Church, and still found time to be the first president of the State Pioneer Society and president of the Pioneer Society of the Saginaw Valley.

James Shearer

Shearer (1823–1896) was one of Bay City's noted architects. In addition to an elegant residence at 701 Center that he built in 1876, he also built three commercial structures (with his brother, George) that are well known in Bay City: the Shearer Block (1866) later housed the Mill End store; the Central Block (1880), which was demolished in 1940 for the Kresge store; and the Shearer Brothers Block (1886), which still stands at Center Avenue and Adams Street. Shearer was appointed as one of three commissioners for the building of the Michigan Capital Building in Lansing, for which his leadership skills were highly lauded. He also served as a bank president, a library board trustee, and a board of water works president, among other appointments. The Central and Shearer Brothers Blocks are seen (below) around 1888, between Washington and Adams.

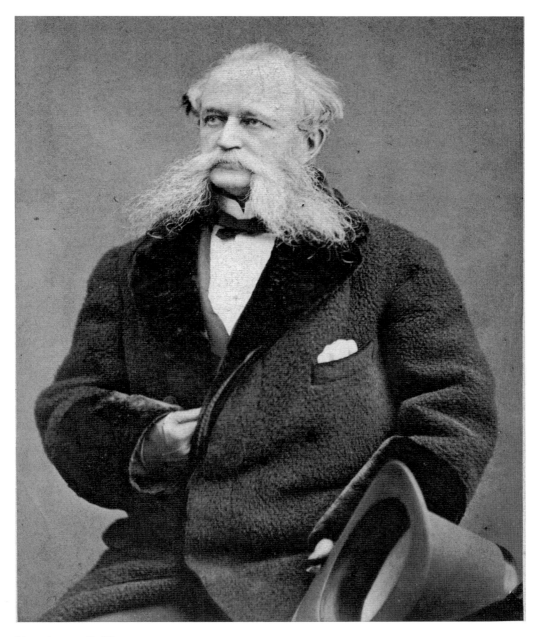

Hon. James G. Birney
Birney (1817–1888), son of James G. Birney (II) who helped found Lower Saginaw, purchased his father's interests in the area and moved here in 1856. He was responsible for ensuring the name of Lower Saginaw was changed to Bay City. He was the acting governor of Michigan at the start of the Civil War. Later that year, he resigned that position to accept an appointment as a circuit court judge. Four years later, he was renominated for the judicial seat but failed to get reelected. He later started the *Bay City Chronicle* in 1871, which became a daily in 1873 and later merged into the *Bay City Tribune*. Birney was also appointed as the US minister at The Hague in 1876, where he served with distinction.

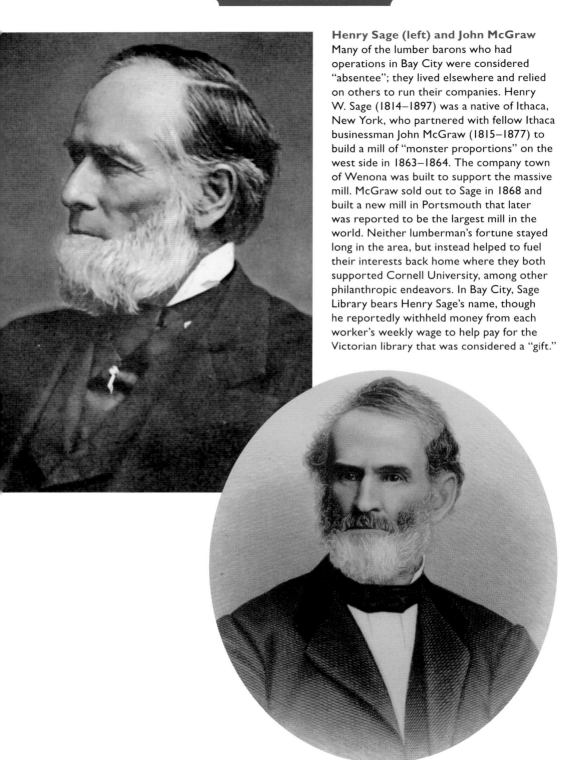

Henry Sage (left) and John McGraw Many of the lumber barons who had operations in Bay City were considered "absentee"; they lived elsewhere and relied on others to run their companies. Henry W. Sage (1814–1897) was a native of Ithaca, New York, who partnered with fellow Ithaca businessman John McGraw (1815–1877) to build a mill of "monster proportions" on the west side in 1863–1864. The company town of Wenona was built to support the massive mill. McGraw sold out to Sage in 1868 and built a new mill in Portsmouth that later was reported to be the largest mill in the world. Neither lumberman's fortune stayed long in the area, but instead helped to fuel their interests back home where they both supported Cornell University, among other philanthropic endeavors. In Bay City, Sage Library bears Henry Sage's name, though he reportedly withheld money from each worker's weekly wage to help pay for the Victorian library that was considered a "gift."

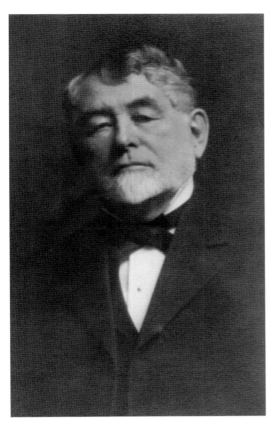

Hon. Spencer Oliver Fisher

Fisher (1843–1919) started the S.O. Fisher and Company in Wenona in the mid-1860s. In 1871, they were contracted to cut 4,000 acres in Williams Township where he later started the village of Fisherville. In 1889, he started the electric street railway in West Bay City and the Bay City and West Bay City Street Car Company, which developed the bayside resort of Wenona Beach in the late 1880s. Fisher founded the Lumberman's State Bank of West Bay City and ran it for more than 25 years, and formed and served as president of the West Bay City Sugar Company in 1899. He was elected to the US Congress for two terms, served as mayor of West Bay City in 1883, and was the 1894 Democratic candidate for governor. He was also among the leading advocates of creating West Bay City in 1877 and "Greater Bay City" in 1903.

Architects' Concept of Elm Place

Elm Place, his palatial 40-room Queen Anne–style mansion completed in 1890, was noted as the largest frame residence in Michigan at the time and among the finest homes north of Detroit. Local architects Pratt and Koeppe designed the South Mountain Street (West Side) residence, which was razed in 1928.

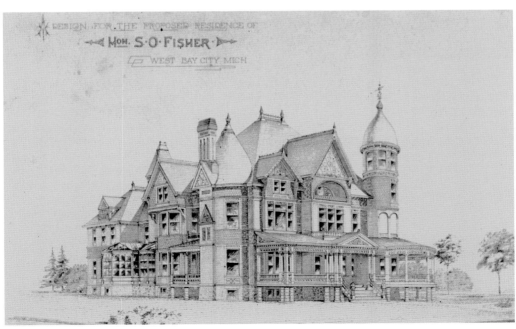

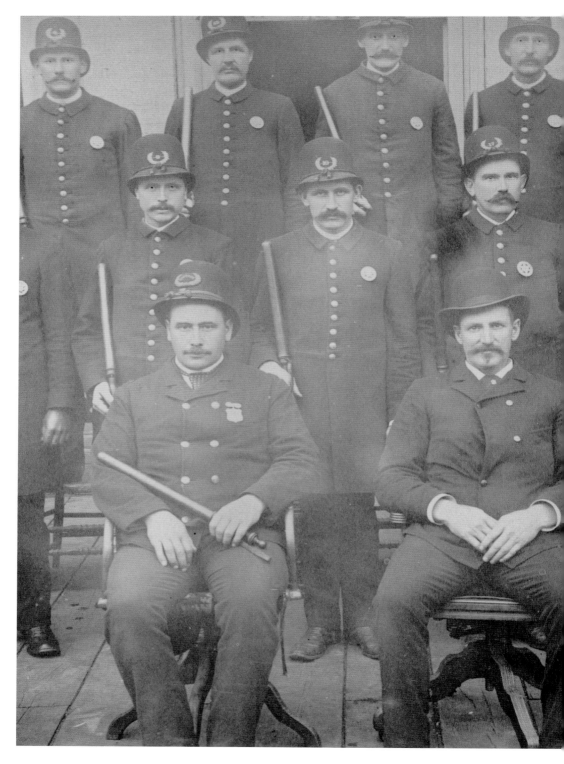

Lumber-Era Bay City Police Force
Bay City's early attempts at law and order were inconsistent, sporadic, and often left up to volunteer "vigilance committees." The influx of shanty boys, sailors, and traders increased the need for a more permanent police force, which happened in 1881. Policemen of that era needed to be tough. Nate Murphy (seated, second from left) was "of powerful physique," and had a reputation for rarely using a weapon to subdue perpetrators. Murphy rose through the ranks to become one of Bay City's highest regarded police chiefs, serving for 37 years. After an illustrious career, he died in 1922 at 81 years of age.

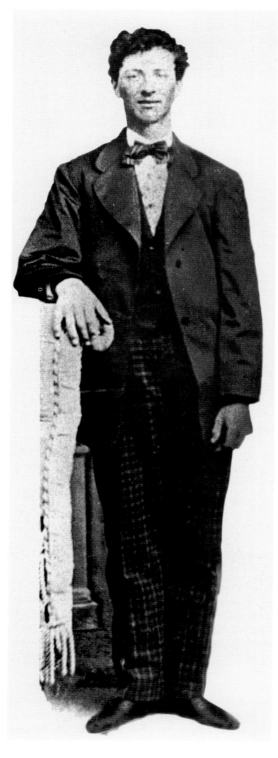

Fabian Joe Fournier

Fournier was born in Quebec around 1845 and moved to the Banks area (French-town) after the Civil War. "Saginaw Joe" (one of his nicknames) started in the lumber camps of the AuSable River region, north of Bay City, where he quickly worked his way up to foreman due to his considerable strength and skill with an axe. He was about six feet tall, 180 pounds, with huge hands and a double row of top and bottom teeth. It was said he used his teeth to take chunks out of the bar at local liquor establishments. It was also claimed that he used his head as a battering ram and fought with his caulked-booted feet. A brawler, like many shanty boys, Fournier frequented many of the local saloons and houses of entertainment from Bay City to Saginaw and to Midland County and beyond. At the well-known Red Keg Saloon in Averill, Fournier tangled with another woods legend, "Silver Jack" Driscoll. This "fight of the century" was fought to a draw, neither besting the other. On November 7, 1875, Joe Fournier boarded the steamer *Daniel Ball* for one of the excursions to Bay View (a resort on Saginaw Bay), sponsored by a local liquor dealer. Fournier started to terrorize the passengers with a group of fellow shanty boys. By the time they got back, it was dark and Fournier staggered down the Third Street dock gangplank where Adolphus "Blinky" Robertson (one of the men who was on the trip) walked up behind Fournier and slammed him in the back of the head with a ship's carpenter's mallet wielded with both hands. The blow killed Fournier, who was only around 30 years old and left a wife and two small children. Robertson was captured a day later in Saginaw. The coroner's inquest found that the blow from the mallet fractured Fournier's skull above the left ear. In the ensuing trial for murder (Fournier's skull was even presented as evidence), Robertson was found not guilty of murder. On January 28, 1876, Robertson walked out of the courtroom a free man, likely due to the fact that Joe Fournier was so disliked among his fellow men. Local author D. Lawrence Rogers later theorized that Fournier's exploits were one of the models for the tales of Paul Bunyan.

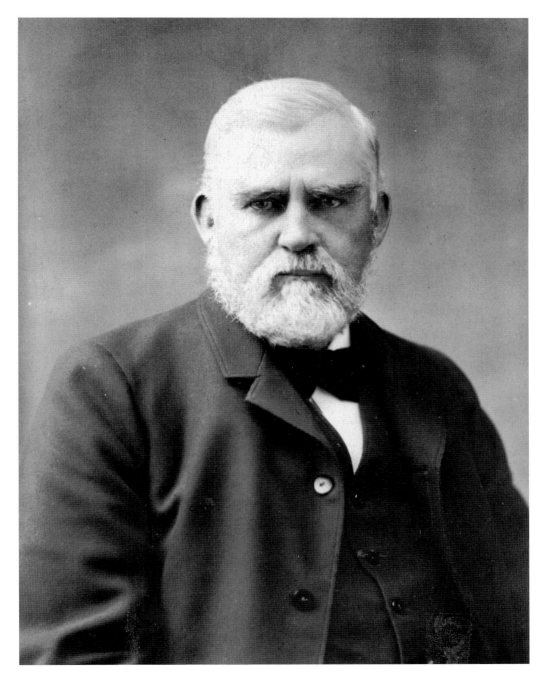

J.R. Hall
The largest shingle mill in the Saginaw Valley was owned by Hall. Built in 1870, it was credited as a factor in the founding of the village of Essexville and alone accounted for one-half of all shingles produced in Bay County in the early 1880s, at one time producing 6,000 shingles per hour. Hall's mill was located along the river at the foot of Scheurmann Road.

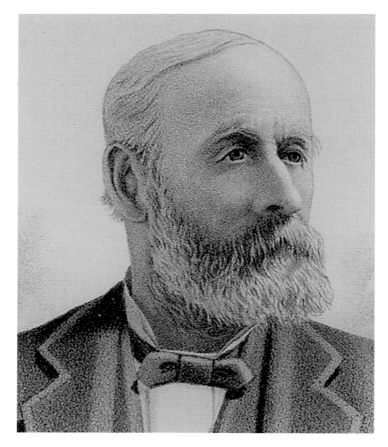

Bay City Mayor George H. Shearer

"Ten Hours or No Sawdust!" was the rallying cry behind one of the first labor "movements" in area history, when Bay City's sawmill workers stood against mill owners for better working conditions. After an unsuccessful strike in 1872, a drop in the price of lumber in the spring of 1885 caused a drop in the average wage for mill workers from $1.98 to $1.77. Old rally-cries of shorter days cropped up as workers struggled with the reduction in wages. In July, 2,000 men (mostly German and Polish workers) held a rally at Madison Park in a sign of support for their demands for a 10-hour day and higher wages. Backed by local merchants who extended credit to the striking workers, the strike also gained the support of the local newspaper editor, Bay City mayor George Shearer, and the local authorities. Michigan governor Russel Alger arrived on July 14 to address the crowd of strikers from the porch of the Fraser House hotel and implore them to go back to work. After this failed, he called in the state militia. At that point, even the Knights of Labor who helped organize the strike encouraged the strikers to go back to work rather than see things turn bloody. W.B. Rouse, a Bay City mill owner, was reported to have said, "My dock and salt sheds are full, and I don't care to run. It would be a benefit to me if the strike did not end for a month." His comment was typical of the reaction of mill owners to the strike, a major reason why the strike did not work. Bay City mill owners who needed lumber processed simply sent their logs upriver to Saginaw mills. The majority of Bay City's absentee mill owners did not take an interest in their workers' well-being. As September neared and the winter-season mill shutdown was inevitable, most workers had no choice but to return to work. Even though the strike was a failure, it did lead to the formation of the labor union, which ultimately offered a unified voice for workers in a particular industry.

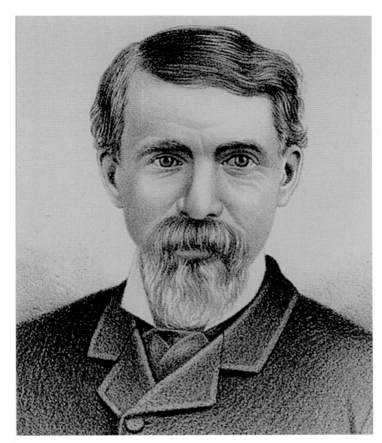

Michigan Governor Russel A. Alger
Alger addressed the strikers on July 14.

Sage Mill
This image depicts the workforce typical of the time.

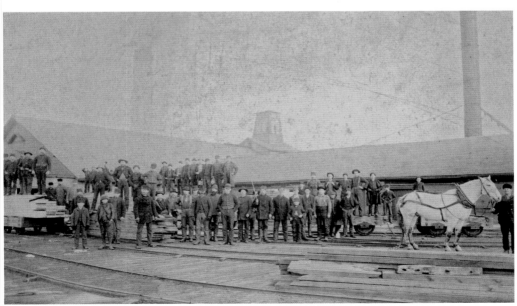

Mendel Bialy, c. 1875
A native of England, Bialy (1852–1948) came
from Detroit to Bay City in 1872 to manage
the books for the Hitchcock Mill, becoming
superintendent in 1878. He later went into
partnership in the Hitchcock and Bialy mill
located at Cass Avenue on the Middlegrounds.
Bialy was long in the lumber business and later
became president and treasurer of the West Bay
City Sugar Company in 1898.

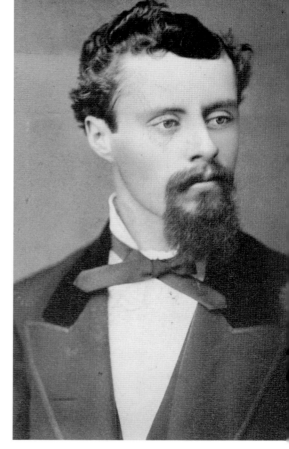

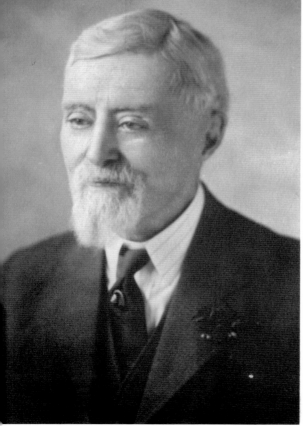

Mendel Bialy, Later in Life
Bialy was no stranger to politics and was well
known around Bay City. He was a state senator
from 1895 to 1896, and at one time, alderman
and president of the Bay City council. He was
the last man left of the original complement
of 75 who organized the Peninsular Guard in
1872. He also erected a lodge building for the
International Order of Odd Fellows (IOOF) at
32nd Street and Broadway Avenue.

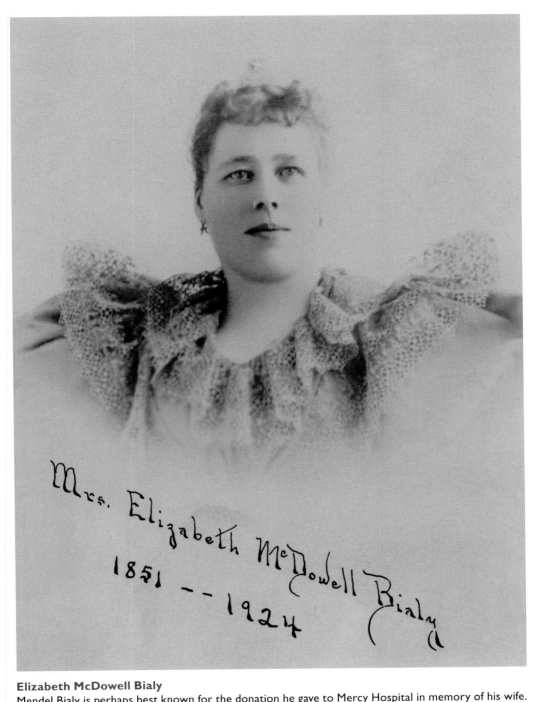

Mrs. Elizabeth McDowell Bialy
1851 -- 1924

Elizabeth McDowell Bialy
Mendel Bialy is perhaps best known for the donation he gave to Mercy Hospital in memory of his wife.
The Elizabeth McDowell Bialy (1851–1924) home for nurses was given to the hospital on June 28, 1927,
as a home for the many nurses who went to the Mercy Hospital School of Nursing. Mrs. Bialy had a
"sincere regard for the Sisters [of Mercy]" who ran the hospital and school.

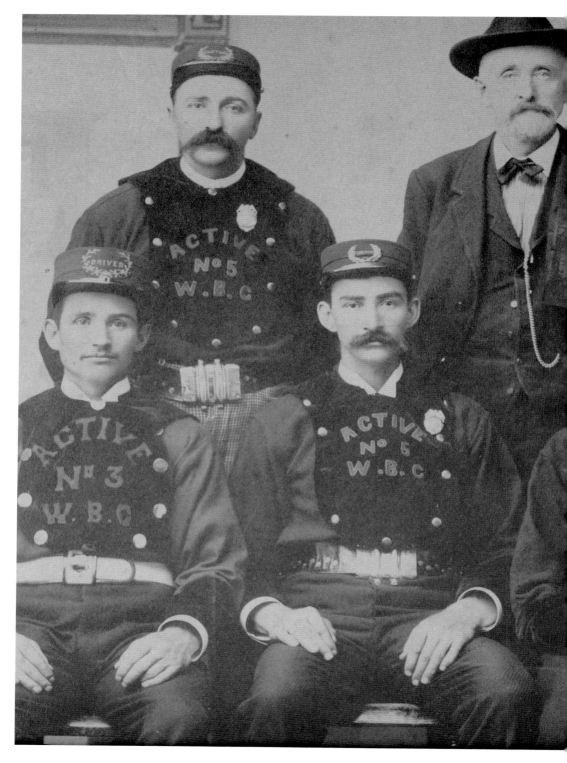

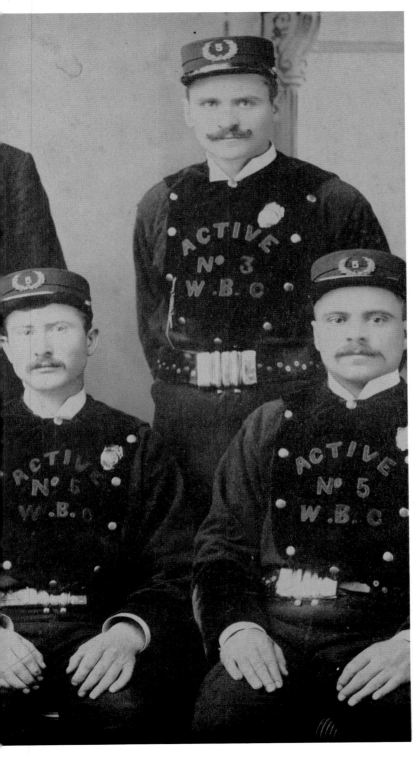

Active Company, West Bay City Fire Department, c. 1890 Stacks of lumber, sawdust, and active machinery are the ingredients for a disaster. The booming lumber town of Bay City found out early that there was a great need for adequate fire protection, especially since the majority of the town was made of and founded on wood. By 1868, there were three fire companies on the east side and the Active Company on the west side. In 1873, a professional force was started when service pay was offered. Early firefighting apparatus were steam powered and even included the Geyser, a tugboat equipped with firefighting equipment. The fire department acquired motorized units in 1911.

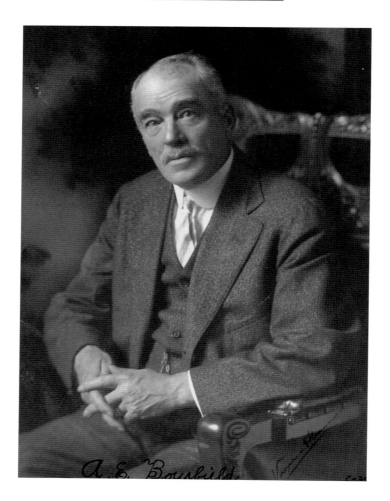

Alfred E. Bousfield

Bousfield (1855–1937) came to Bay City in 1875 and purchased (with his brother, Edward) a small woodenware company, which became the largest manufactory of its kind in the world. The plant was located at the foot of 34th Street and had been established only a few years earlier in 1868. They made pails and tubs of all kinds, an estimated 20,000 per day at the height of business. Churns, water pails, tobacco pails, candy shipping pails, butter and lard pails and tubs, and specialty containers were shipped all over the world from the port of Bay City. Bousfield and Company was a major success, even after an 1890 fire destroyed the mill. Insurance did not cover a substantial part of the loss, but after only six months they had the production back up and running in a larger and more modern plant. A.E. Bousfield retired in 1916, a well off and well-regarded Bay City resident. The plant was then sold and became the home of the Hanson-Ward Veneer Company. Bousfield was married to Carrie Lockwood from Cleveland and they had two daughters. He built a steam yacht *Outing*, for the family to use on the waters of the Great Lakes. He hunted, fished, and was a camera enthusiast in his spare time. In 1888, Bousfield invested in the Les Cheneaux Club on Marquette Island, Les Cheneaux Islands (near Cedarville, Michigan, on northern Lake Huron). The intent of Bousfield and the other investors, many from Bay City, was to help attract summer people to build summer cottages at the club, which occupied part of the large island. He was also a Knights Templar, a 32nd degree Mason, and a member of the Detroit Mystic Shrine.

CHAPTER TWO

Community Leaders

Let us be content to leave our Work, knowing that for the day and the place it has been well done. May this rich country that We have helped to reclaim to civilization and human happiness be ever guided in affairs of business and State by a higher Wisdom and a No less Sacrificing and unselfish spirit than that Which, in the rude and Sparsely Settled Wilderness, governed by the pioneers of the Saginaw Valley.
—William R. McCormick, 1874

Many of the earliest leaders of the community were either pioneers themselves or came to the area while the original settlers still held sway in community affairs. Hon. Sydney Campbell was an early settler, businessman, and probate justice who was endeared to the local community. Some of the most notable leaders were involved in multiple endeavors, including the practice of law, finance, lumbering, and investing. Hon. Sanford Green and Hon. Isaac Marston were highly regarded in the legal field not only for their decisions from the bench, but also for their contributions to the field through mentorship and instruction. Oscar Baker Sr. started a family legacy that saw two generations of significant legal work and service to the community. Hon. Thomas E. Webster's photographs helped document the lumber-era growth of Bay City and beyond. Hon. Samuel G. Houghton and Hon. Arthur Tuttle both served with distinction in the higher courts. John C. Weadock's name became synonymous with excellent legal representation and was immortalized in the power plant that bears his name. Horace Tupper, MD, was the area's early pioneer in the medical profession. Mayors Robert Mundy, Gustaves Hine, Nathan Bradley, M. Monte Wray, and Anne Hachtel all made significant contributions to the success of Bay City. Wilbert Gustin shaped the way in which news was distributed in the area. Richard Fletcher and Eugene Fifield were business leaders during critical times in Bay City's history. George W., Ira, and George E. Butterfield represented three generations of a family that helped educate young minds and preserve Bay City's past. Politicians J. Bob Traxler, James Barcia, and Tom Hickner helped Bay City move forward through their representation at the local, state, and national level. Ron McGillivray's vision and leadership helped bring significant improvements to the city including Veterans Memorial Park.

Hon. Sanford M. Green

Archibald McDonell of the Bay County Bar Association said it well in his funeral tribute for Green: "It would be difficult to find one man who has done more for the bar of this state than he because he was in his attainments, an extradinary [sic] man. In reviewing his life we see that he began at the bottom of his profession and rose step by step to the highest position in the judiciary of this state, a member of the Supreme Court. He was noted, not so much for his brilliancy, but for the evenness of his character and nature, for he was always doing the right and proper. He was independent and paucity of riches bore no influence with him. He was invariably dignified and courteous in his relations with all men and always ready to aid and correct. Personally I owe to Judge Green a debt for the law learning I have gathered. His hand book has been a great help to younger as well as older members of the bar and in looking over his life we find few men like our deceased brother. His rulings were always based upon fairness and the mercy of the wise and in him we have lost a true and devoted friend and adviser." Sanford Moon Green (1807–1901), originally from New York, studied law for five years and was admitted to the New York Bar in 1834. In 1837, he came to Michigan and took several public positions in Shiawassee County. He was elected to the State Senate in 1842 and appointed to the state supreme court in 1844. After various court services, he resigned in 1867 and moved to Bay City, resumed his law practice, and was appointed judge of the 18th circuit in 1872, retiring in 1887. His counsel was sought by many and he wrote two books, one on practical law and statutes of Michigan, and a third entitled the other entitled *Crime, Its Nature, Causes, Treatment and Prevention*. Published in 1889, this book attracted wide attention for his consideration of the majority of crime as a disease that should be morally treated with reference to the good of the offender as well as society.

Hon. Isaac Marston

Marston (1849–1891) was born in Ireland and at the age of 16 came to the United States to seek better opportunity. The former grocer's apprentice studied law at the University of Michigan, graduating in 1861. In 1862, at the urging of Judge James G. Birney, he relocated to Bay City, where he built a small cottage and set up a law practice, which quickly became highly regarded. He was a prosecuting attorney for Bay County and later state attorney general for a time before becoming the youngest Michigan Supreme Court justice in 1875. He served on that bench with distinction until 1883 when he retired. True to his agrarian roots, he kept a farm called "Riverside" along the banks of the Kawkawlin River near Old Kawkawlin Road.

Hon. Sydney S. Campbell

"Wonderful, wonderful . . . who would have thought it!" were the words spoken by an elderly Judge Sydney S. Campbell (1804–1887) while reflecting about the community that he watched grow for over 50 years from a few buildings in the wilderness to a bustling Bay City. Judge Campbell was one of the very first settlers to locate in Lower Saginaw (eventually Bay City) and create a permanent home. He was born in Paris, New York, in 1804 and came to Michigan in 1830 to settle in Pontiac. In 1836, he moved to Cass River Bridge where he laid out the town of Bridgeport. Unfortunately, the new community was hit with hard times and Judge Campbell was convinced by James Fraser in 1838 to move to a new town near the mouth of the Saginaw River called Lower Saginaw. Shortly thereafter, he built and opened the Globe Hotel, which included a tavern, in what would later become downtown Bay City. Judge Campbell was very influential in the development of the community in many ways and highly regarded by Bay City's residents. He was elected the first supervisor of Hampton Township in 1843 (besting James G. Birney by one vote) and held that office for many years. He was also appointed judge of probate of the newly formed Bay County in 1857, a position he held for 12 years. In 1873, he constructed a brick business on Water Street that he rented out. The last 20 years of his life were spent retired to his small farm at the corner of Johnson and Woodside. Judge Campbell and his wife Catherine had five children, several of whom preceded him in death. William McCormick stated in his memoirs that Judge Campbell was the most widely known man of any person in Northern Michigan among both "Indians and Whites." He was a great hunter and for this reason the Indians called him "Che-Me-gun" meaning "Big Wolf." At the time of his death, one son and two daughters still resided in Bay City.

Hon. Thomas E. Webster in His Parlor at 900 Fifth Avenue, c. 1883

Webster (1848–1940) was a lawyer who came to Bay City in 1874 and was admitted to the bar shortly thereafter. He became a probate judge in 1881 and served two terms. Webster was a member of the Mutual Building and Loan Association and Bay City Board of Education, and helped to form a semi-pro baseball team. He lived at 900 Fifth Street for many years and when he died, he was the last Civil War veteran and last member of the Grand Army of the Republic (GAR) in Bay City. Webster was also an amateur photographer and left behind a large collection of glass plate negatives that show the development of Bay City and the surrounding area through his camera lens —as shown by this photograph of the Federal Building being built, c. 1890.

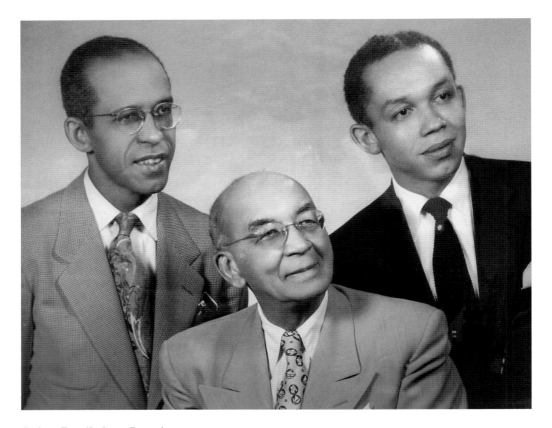

Baker Family Law Practice
Two generations of the Baker family law practice are pictured c. 1951 from left to right: Oscar Baker Jr., Oscar Baker Sr., and James Baker. L.E. Joslyn, a prominent white attorney in Bay City, gave African American attorney Oscar W. Baker (1879–1952) his first chance to practice law in 1902 when he asked him to join his law firm. Oscar W. Baker had lost the lower part of his left leg in an accident with a train in Bay City as a child of 11; however that incident fueled his desire to succeed. For the era, Joslyn's offer was very extraordinary; Baker took that opportunity and used it as a stepping stone to create his own thriving practice a few years later. Baker had graduated from Bay City High School, Bay City Business College, and the University of Michigan (1902) with a law degree. He was asked to serve as president of the Freedmens Progress Commission in 1915, was a circuit court commissioner for one term, and served on many committees and boards, including the Bay City Board of Commerce. Baker married Ida Harrison in 1910 and had nine children. Two of Baker's sons, Oscar Jr. and James Weldon, became prominent lawyers in their own right. Oscar Jr. (1911–2000), a 1935 graduate of the University of Michigan law school, was a highly successful trial lawyer and a community fixture for many years. He headed Bay City's first chapter of the NAACP in 1956 and was highly regarded for his work on civil rights cases during the 1950s and 1960s. James W. (1924–2003), a World War II veteran, later graduated from the University of Michigan in 1951 with a law degree and had a very successful practice thereafter with his father and brother. He was the first African American president of the Trial Lawyers Association, the first African American elected to the American Society of Barristers (1981), and in 1969 he received the prestigious Arthur Von Briesen Award for service to the legal field. He and his wife Joy, a public school principal, were well known within community circles and major supporters of the United Negro College Fund. All three Bakers hold high distinction within the history of the legal system in the State of Michigan. (Courtesy of Joy Baker.)

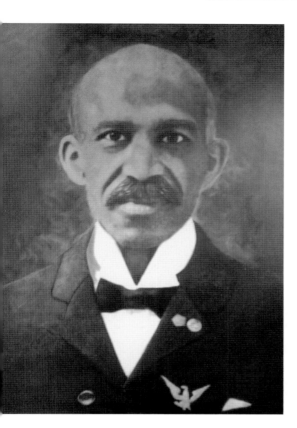

James H. Baker

The patriarch of the Baker family and the father of Oscar Baker Sr., James H. Baker came to Bay City shortly after serving in the Civil War. He was considered a pioneer in the advancement of colored citizens in government and politics, including as a candidate for land commissioner in Bay City, on the People's Party ticket in 1898. He was a Master Mason, Royal Arch Mason, and member of other local organizations and societies. (Courtesy of Joy Baker.)

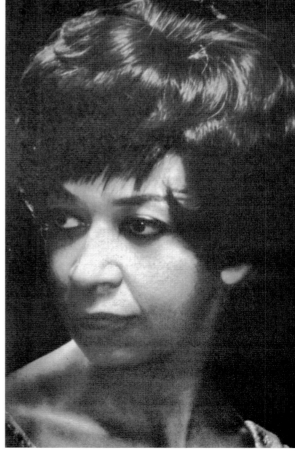

Elaine Baker

One of the nine children of Oscar Baker Sr., Elaine Baker (1925–unknown) was a gifted singer who made her first public appearances in 1934 at age nine, at the WBCM children's show at the Washington Theatre. Harold Russell Evans at Central High School encouraged her to follow a career in vocal arts, a career path that led her to tour the world for many years. She received an American Theatre Wing award in 1954.

Hon. Samuel G. Houghton

Houghton (1865–unknown) was a justice of the 18th District Court from 1917 to 1935. The attorney for West Bay City, in 1903 he helped draft the consolidation charter for West Bay City and Bay City. Judge Houghton was later one of the driving forces behind the new Bay County Building, which included a new office and courtroom, considered among the most impressive in Michigan when the building was built in 1933; he presided over the cornerstone ceremony.

Hon. Arthur J. Tuttle

Justice Tuttle (1868–1944) was appointed to the United States District Court for the Eastern District of Michigan on August 6, 1912, by President Taft. Originally from Leslie, Michigan, Justice Tuttle's new district included the Federal Courthouse in Bay City. During his 32-year tenure, he presided over several high-profile cases, including the trial and sentencing of Anthony Chebatoris for a foiled bank robbery in Midland in 1937 that resulted in the murder of a Bay City resident. Chebatoris was hanged for the crime on July 8, 1938, the only execution ever to take place within Michigan's borders since statehood in 1837. Tuttle's tenure on the bench ended with his death in 1944.

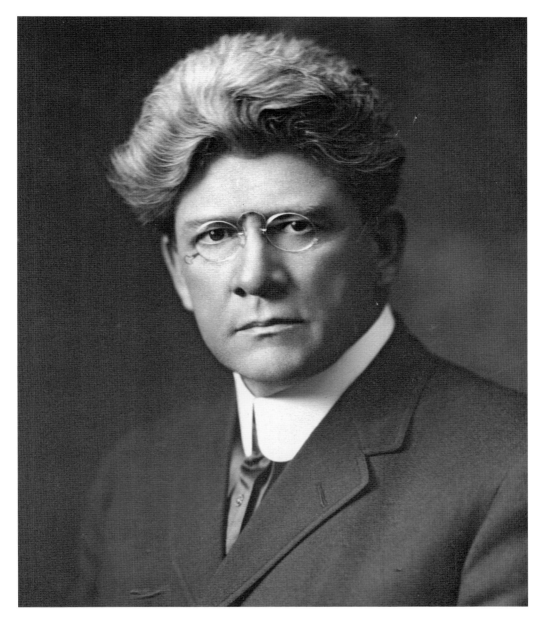

John C. Weadock

Mention the name Weadock and most people think of the Consumers Power plant that shares the name with "Karn." The earlier of the two complexes was named after John C. Weadock (1860–1950), a Bay City attorney who was among the first to advocate for the merger of east and west. He also helped establish the northern division of the eastern district of the US District Court in Bay City. He was instrumental in the formation of Mercy Hospital, a director of People's Commercial and Savings Bank, and a charter member of Elks Lodge 88. He shared a law practice with his brother, Thomas A.E., who was later a justice and member of Congress. In 1940, Consumers Power Company honored him by naming the new power plant in his honor; he was a past director and founding member of the company.

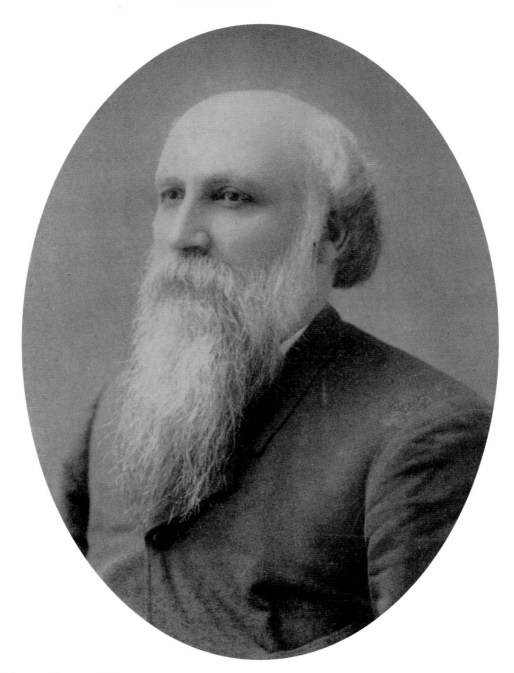

Horace Tupper, MD

Dr. Tupper (1830–1902) was a leader in the establishment of proper medical care in the Bay City area. After a tour as a surgeon in the Civil War, Dr. Tupper came to the Saginaw Valley in the mid-1860s with a keen interest in developing a new system of salt production. For many years, he was the only accredited surgeon in the area. He was one of the organizers of the Bay County Medical Society and of the Michigan State Medical Society, and continued to practice medicine throughout his life.

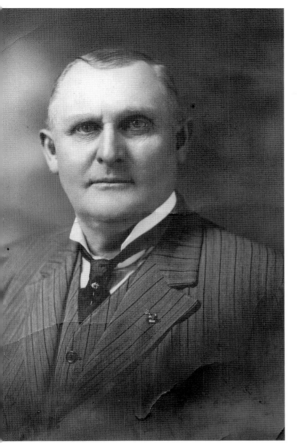

Richard H. Fletcher

Fletcher (1858–1933) was born in rural western Bay County and educated in a "log school" for much of his early life. He later entered the lumbering business, working his way up to foreman. He was state labor commissioner under Governors Warner and Sleeper, and then entered the insurance business. Fletcher Auto Sales was chief among the other business interests he had in the area.

Robert Vail Mundy

Mundy (1854–1940) came to Bay City in 1871 with little and through hard work amassed a substantial fortune by the time he died, having been president of the Bay City Hardware Company, treasurer of the Berdan Bread Company, and a "substantial gentleman farmer." He was a wartime mayor of Bay City, serving from 1917 until 1921. The *Bay City Times* said of Mundy, "A most genial man inherently, he was known as a sturdy fighter for any cause which interested him sufficiently to summon his aggressive abilities into action."

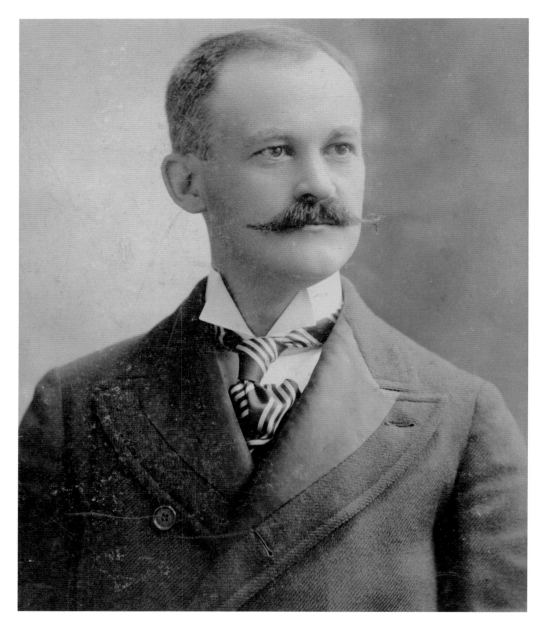

Wilbert H. Gustin

One of the early editors and managers of the *Bay City Times* was Wilbert H. Gustin (1856–1927). He was born in Canada and came to Bay City in 1864. He joined his brother in the job printing business until 1879, when he became a newspaper reporter. In 1889, Gustin started the *Bay City Times* and later became the managing editor until 1927. Gustin married Harriet E. Cumming and they had three children, one of whom was Harriet Gustin Campbell, who in her later years wrote a column for the *Bay City Times*. Gustin was a member of the Knights of Pythias, Elks, and an early member of the Bay City Rotary Club. Gustin also was a founding member of the Bay County Historical Society and the first volunteer curator of the museum collection.

Gustaves Hine

Hine (1842–1925) emigrated from Germany to America in 1855 with his parents when he was 13. He became a successful businessman and was well known for his meat market in Bay City and as director of the German American Sugar Company. Hine became active in the consolidation of West Bay City and Bay City and his reputation as a capable and fair administrator helped him become the first mayor of the consolidated Greater Bay City in 1905, a position he held for three consecutive terms.

Nathan B. Bradley

Bradley (1831–1906) was elected the first mayor of the consolidated Bay City/Portsmouth in 1865 when the city received its charter. He served Bay City and Michigan in many capacities as a state senator and US congressman. Mr. Bradley was a lumberman by profession, a director of the Michigan Salt Association, principal stockholder and vice-president of the First National Bank, and a member of the Masons and Knights Templar.

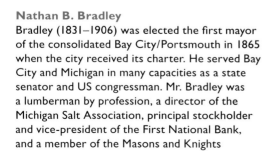

45

Monte Wray Jr. (standing) with Frank Braman, c. 1965
Lincoln-Mercury automobile dealer Monte Wray Jr. (1926–2004) surprised local politicians by running against three-term mayor James L. Tanner in the 1962 mayoral election, a race Wray won by 62 votes. The highly regarded community figure went on to serve three terms as mayor. He was a decorated World War II veteran, a Northwood University automotive marketing instructor, and heavily involved in the area Jaycees. He was also president of the Michigan Auto Dealers Association. The national Chamber of Commerce lauded Wray as one of the leading men of the USA in 1963. Wray was married to Helen Defoe and they had four children.

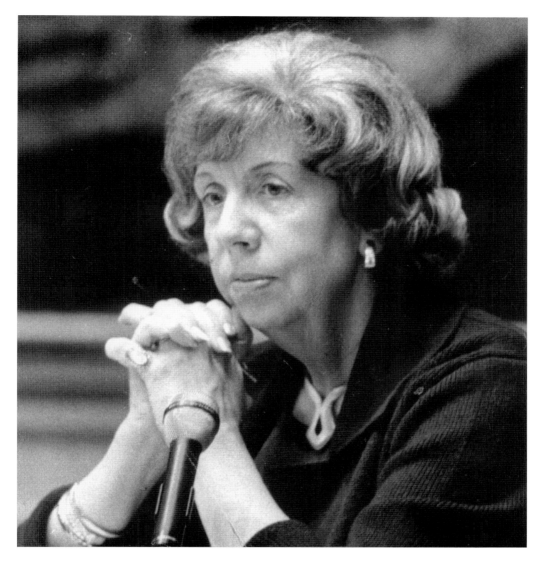

Anne Russel Hachtel

Hachtel (1925–2003) started in area politics at an early age, which eventually led to her election as Bay City's mayor in 1980, the first woman elected to that office. She served three and a half years before resigning to take a position with the Bay Area Convention and Visitors Bureau. A realtor by trade, Hachtel owned Hachtel Realty with her husband, Robert. She was a member of the Bay County Board of Realtors and the Euclid Business Association. Mayor Monte Wray appointed Hachtel to the first citizens' advisory committee, which ultimately helped implement the first urban renewal program for Bay City. She later served as chair of the group, which was instrumental in the development of Smith Manor, the first high-rise for the elderly built in Bay City. Urban renewal became a theme of Hachtel's political career throughout the rest of her tenure. She credited her years working in the real estate industry for the special insight it gave her into Bay City. "Let's face it real estate is what cities are all about. Realtors must know their community and its people." Both Hachtel and her husband were involved in many local organizations including the YWCA.

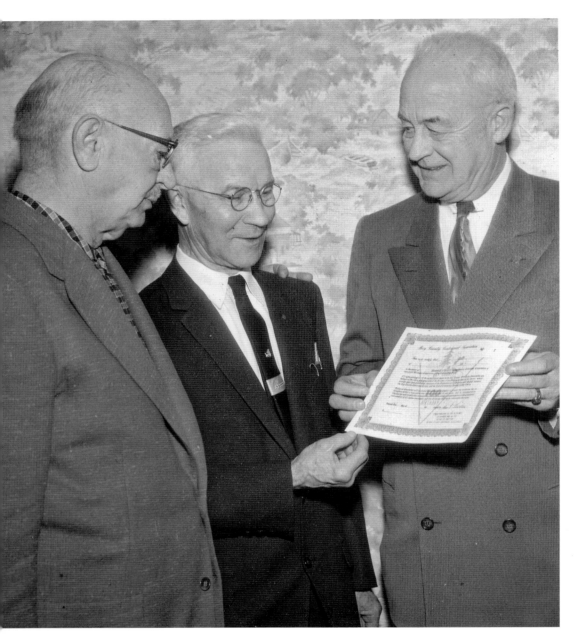

George Ernest Butterfield

Butterfield (center) receives Bay County Centennial stock certificate No. 1 from Russell J. Shafer, chairman, and D. Dalzell, president, of the Bay County Centennial Executive Committee in 1957. The award was for the new county history book he was writing to release at the centennial. Butterfield (1883–1975) published *Bay County Past and Present* that year. The dean emeritus of Bay City Junior College had expanded his original 1918 "blue" version of the book in honor of the centennial. It remains a standard history on Bay County to this day. He was one of the early members of the Bay County Historical Society who helped ensure the success of that organization.

George W. Butterfield

Butterfield (center with beard, 1843–1919) was the father of George E. Butterfield. A Civil War veteran, he came to Bay City after the war and in 1889 began working as a mail carrier, a job he held for 30 years. He was the oldest mail carrier in Bay City at his death. He was also a member of the board of education for 12 years. This image was taken from a postal carriers' photograph around 1912.

Ira Butterfield

Ira W. Butterfield (at right, 1915–1994) was the son of George Ernest Butterfield and a native of Bay City. A graduate of Bay City Junior College and University of Michigan law school, he was a practicing attorney for 28 years and later served as a district and circuit court judge until retiring in 1981. His contributions to the Bay County Historical Society (past president) and the archaeological community helped further Bay City residents' understanding of their community's past. This photograph was taken in 1963 at the Historical Museum in the Bay County Building.

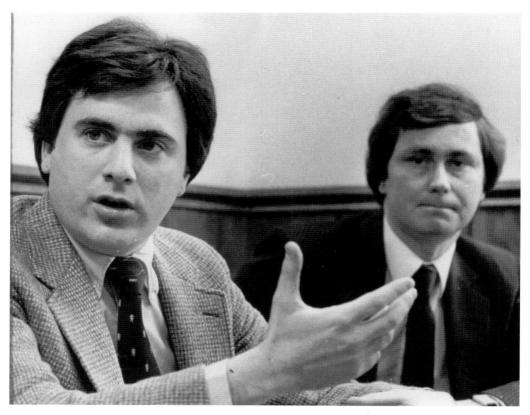

Rep. Tom Hickner (left) and Sen. James Barcia, c. 1984

James Barcia (1952–present) is well known among Bay City residents, serving his hometown very well during his tenure in government. He was a state representative (1977–1983), state senator (1983–1993), a US representative (1993–2003) and a state senator again (2003–2010) until his retirement. Thomas Hickner (1954–present), a one-time aide for Representative Traxler, served as a state representative from 1982 to 1992 and since 1992 has served with distinction as Bay County's county executive.

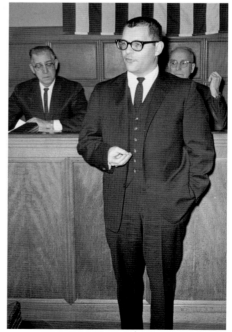

Jerome Robert "J. Bob" Traxler, 1963

Traxler (1931–present), a Bay City area native, became one of the area's best-known politicians after starting in the Michigan House of Representatives (1962–1974), where he was the majority floor leader (1965–1966). He filled a vacancy in the US House of Representatives seat for Michigan's 8th District in 1974 and was subsequently reelected to nine terms, serving with distinction until his retirement in 1993.

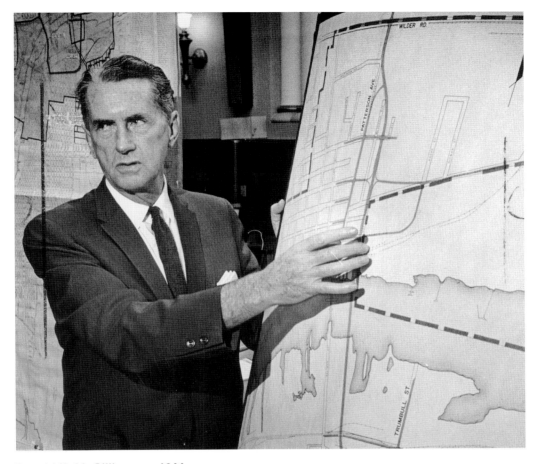

Ronald K. McGillivray, c. 1966

Anyone who has had the pleasure to visit Veterans Memorial Park along the river in Bay City has seen firsthand the product of Ronald McGillivray's vision. McGillivray (1913–2008) first saw the former industrial land and low ground along the west side of the river with a different vision in 1936 when he completed an engineering plan to create a public park. The plan, his master's thesis at the University of Michigan, was given to the city with McGillivray's blessing when the thesis was complete. By 1940, he was hired as Bay City's planner. In 1942, a committee was formed to raise money for Veterans Memorial Park. The area was eventually cleaned up and McGillivray's vision took shape in stages over the next few decades. He moved from city planner after 15 years to director of public works and finally director of community development, completing projects that included the Independence and Liberty Bridges. He retired from the city in 1982, but continued to be active in the community and as a consultant to the Bay County Growth Alliance; he still had a seat on the Bay City Planning Commission at the time of his death. "He's such a modest person but he has great courage and determination," said Clifford Van Dyke, president of the Growth Alliance and longtime friend of McGillivray in a *Bay City Times* article. "He's just been a great friend and terrific to work with. He's been upbeat all along and he's a great problem solver and he just went out of his way to be helpful in any way." In the same article, written after McGillivray's death in 2008 at age 95, Frank Starkweather, vice president of the planning commission, summed up his accomplishments with, "He remained tremendously loyal to the long-term welfare of Bay City. For the longest time, he was a real power in City Hall. I think there was a time when his influence was so great that he held sway over the thoughts of many people, elected officials and fellow staff of the city."

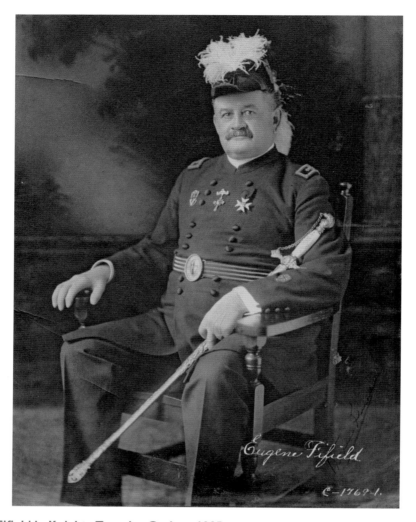

Eugene Fifield in Knights Templar Garb, c. 1905

Historian Augustus Gansser wrote of Fifield (1851–1929) in 1905: "For many years he has been one of the leading members of the Masonic fraternity in Michigan. He is a 33rd degree Mason, receiving this highest honor at Buffalo in 1896. He belongs to Bay City Lodge, No. 129 [Free and Accepted Masons], and Blanchard Chapter No. 59 [Royal Arch Masons]; is past eminent commander of Bay City Commandery, No. 26 [Knights Templar]; is thrice potent grand master of McCormick Grand Lodge of Perfection; is high priest of Bay City Council, Princes of Jerusalem; is past most wise and perfect master of Saginaw Valley Chapter, Rose Croix; is a member of the Michigan Sovereign Consistory of Detroit; and of Moslem Temple, A.A.O.N.M.S. He is president of the Bay City Masonic Temple Association, has been on the finance committee for years and is a trustee, and has long been identified with the Bay County Masonic Mutual Benefit Society." One wonders how Fifield had the time to handle his duties as secretary of the Bay City–Michigan Sugar Company, one of the largest sugar manufactories in the area. In addition, he had several farms, including one of 240 acres in Monitor Township. In fact, he later found a way to combine sugar beets and livestock when he experimented with using beet pulp and molasses for fattening lambs. He was also involved with the Michigan State Agricultural Society and the Tawas Sugar Company.

CHAPTER THREE

Soldiers, Sailors, and Survivors

Hundreds sleep in our cities of the dead, whose achievements in war and peace equal and perhaps surpass these isolated service records, but these will suffice to preserve for the perusal of their surviving comrades, and as an indication to posterity of the character and service of the veterans we delight to honor.
—Augustus Gansser, 1905

So many of Bay City's residents have served in the military, even with distinction, that volumes could be written about their exploits. The GAR erected a monument to those who served during the Civil War, at a site in Pine Ridge Cemetery called Soldier's Rest. Horace B. Mix and Gen. B.F. Partridge both served with distinction during that defining conflict. Over 30 years later, Elmer Meilstrup and William Mattison both served aboard the USS *Maine* during the prelude to what would become known as the Spanish-American War. Meilstrup, a casualty, and Mattison, a survivor, would both unwittingly be involved in one of the most significant events in history, which ended in a declaration of war and cries of "Remember the *Maine*." Great Lakes captain John Mattison sailed into the Black Friday storm of 1916; he survived only to watch his crew, including his nephew Albert Logan, perish in the frigid waters of Lake Erie. Capt. Augustus Gansser's illustrious military career included two wars, and he later became a tireless advocate for his fellow veterans during his political service. The local historian also educated many local schoolchildren with stories of his military exploits in later years. The Second Michigan/128th Ambulance Company served with distinction during World War I. Near the end of that war, local servicemen became "polar bears" serving in the Northern Russia campaign. The Harding-Olk-Craidge American Legion Post 18 was named in honor of three fallen Bay City heroes. The Blue Star Mothers and the American Red Cross served the military and their families in many capacities. Volunteers in the local community have helped to shape both of these organizations over the years.

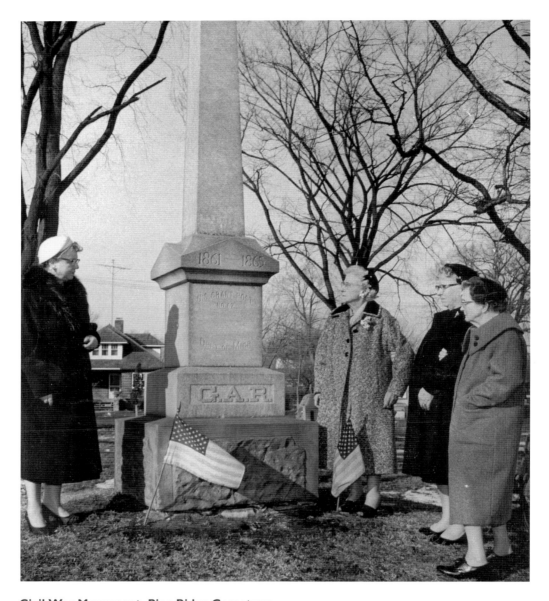

Civil War Monument, Pine Ridge Cemetery
Members of the Bay City Ladies of the GAR are shown at the Civil War monument in Pine Ridge Cemetery in 1961. It was dedicated by the U.S. Grant Post no. 67, GAR, on Memorial Day 1893 to the memory of those in the area who had fought in the War of the Rebellion (1861–1865), and is surrounded by military-issue grave markers. The *Bay City Tribune* included the following in August of 1893: "The monument designed by the G.A.R. posts of this city to perpetuate the memory of the dead soldiers, has been placed in position in Pine Ridge cemetery. It is of Whitney granite resting on a base of the same material, and stands on a mound three feet high. On the sides of the monument are the following inscriptions: 'They saved their country and fought for freedom. They are quietly sleeping under the Red, White and Blue.' 'To preserve and strengthen those kind and fraternal feelings which bind together the soldiers and sailors of the rebellion.'"

Horace B. Mix

Mr. Mix (1841–1912) enlisted in the US Engineers, Veteran Corps, during the Civil War. Wounded at Vicksburg in 1863, he spent the next 11 months recovering, after which he was sent to West Point for the remainder of the war to instruct new recruits in the engineering trade. Mix then settled in Bay City where he worked in the lumber business for N.B. Bradley and Sons. He died after a lengthy illness and was buried in Elm Lawn Cemetery.

Brig. Gen. Benjamin F. Partridge

General Partridge (1822–1892) moved to Lower Saginaw in 1854 to work in the lumber business. He also entered a life of public service, as the first supervisor of Portsmouth Township and later as sheriff of Bay County, a position he resigned to recruit troops for the Union Army at the outbreak of the Civil War in 1861. Partridge eventually became colonel of the 16th Michigan Veteran Infantry and later was brevetted brigadier general. Wounded several times during his service, he still managed to fight in all but two of the regiment's 54 engagements including the battle of Gettysburg.

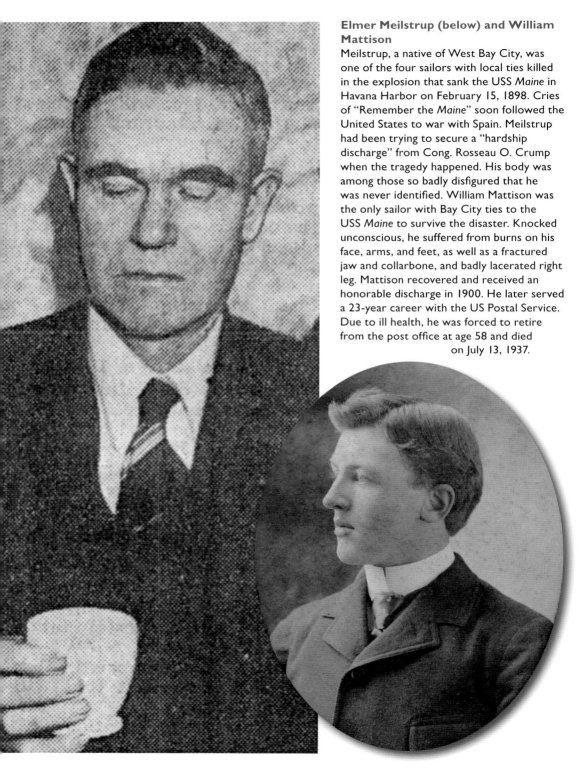

Elmer Meilstrup (below) and William Mattison

Meilstrup, a native of West Bay City, was one of the four sailors with local ties killed in the explosion that sank the USS *Maine* in Havana Harbor on February 15, 1898. Cries of "Remember the *Maine*" soon followed the United States to war with Spain. Meilstrup had been trying to secure a "hardship discharge" from Cong. Rosseau O. Crump when the tragedy happened. His body was among those so badly disfigured that he was never identified. William Mattison was the only sailor with Bay City ties to the USS *Maine* to survive the disaster. Knocked unconscious, he suffered from burns on his face, arms, and feet, as well as a fractured jaw and collarbone, and badly lacerated right leg. Mattison recovered and received an honorable discharge in 1900. He later served a 23-year career with the US Postal Service. Due to ill health, he was forced to retire from the post office at age 58 and died on July 13, 1937.

Capt. John Mattison and Albert Logan (right)

"'Call it hell. That partly tells it. . . . Only thoughts of little ones at home kept me alive,' Says Captain [Mattison]; prayed and cursed at horror as companions died before his eyes." (*Cleveland Leader*, 10/22/1916)

Lake Erie had just experienced the worst storm on record, later known as the Black Friday Storm; 58 sailors perished the evening of October 20, 1916. Capt. John Mattison of Bay City spent 12 hours clinging to the rigging of his wrecked schooner, the *D.L. Filer,* before being the only one of the seven onboard rescued by the steamer *Western States*. The 45-year-old vessel was traveling from Buffalo to Saugatuck with a load of coal and foundered in the storm near Bar Point, near the mouth of the Detroit River. Captain Mattison's young nephew, Albert Logan (also of Bay City), perished in the wreck. His remains were not found until the following spring.

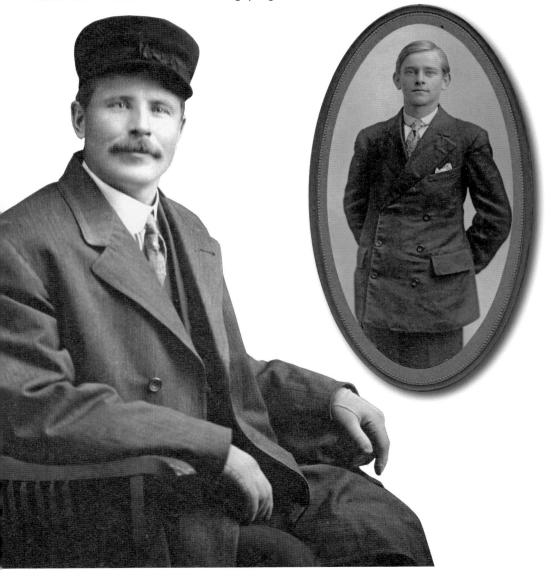

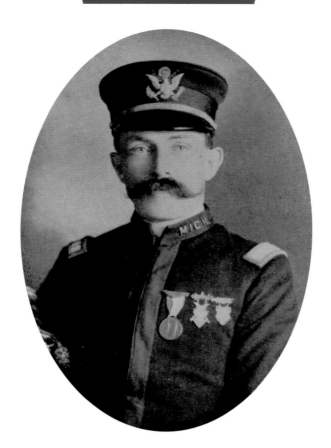

Capt. Augustus Herbert Gansser, Captain Company B, 3rd Michigan Infantry

Gansser was one of Bay City's most famous military veterans as well as a legislator, businessman, advocate for veterans' affairs, and historian. Originally from Wurtemberg, Germany, Gansser (1872–1951) came to the United States with his family in 1873. In 1881, he settled in Bay City, working as a newspaper carrier and mail clerk. He worked at the B.H. Briscoe Box Factory until 1887 when his mother insisted he find a less dangerous occupation. Gansser married Elizabeth Richardson in 1898. He joined the Peninsular Military Company in 1892, quickly rising to the rank of 1st sergeant by 1897. On April 26, 1898, he joined his fellow soldiers in the muster for the Spanish-American War. Gansser witnessed the surrender of Spanish forces in the valley surrounding San Juan Hill and later aided the sick and wounded on the return trip. The Cuban service had a major impact on his health; he lost significant weight and was stricken with fever and ague, which haunted him the rest of his life. He entered the insurance and freelance newspaper fields upon his return home and continued to be active in the Peninsular Military Company. By 1905, he was the senior captain of the entire regiment. That same year he also published the 726-page *A History of Bay County and Representative Citizens*. Gansser was elected to the state house of representatives and served from 1911 to 1913 and was a member of the state senate from 1915 to 1918. In 1917, overseas duty once again called as he mustered into the regular army for service in World War I, serving with the 125th Infantry, 32nd Division (the famous Red Arrow Division). He was wounded at the battle of Chateau Thierry on July 30, 1918, and took over a month to recover. He later received his lieutenant-colonel's commission from Gen. John Pershing. Gansser was again elected to the state senate and served from 1923 to 1932. He also put much of his efforts to work on behalf of his former servicemen while still finding time to relate his war memories to many local schoolchildren and write a weekly column in the *Bay City Times*.

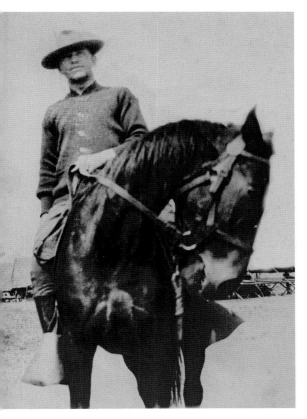

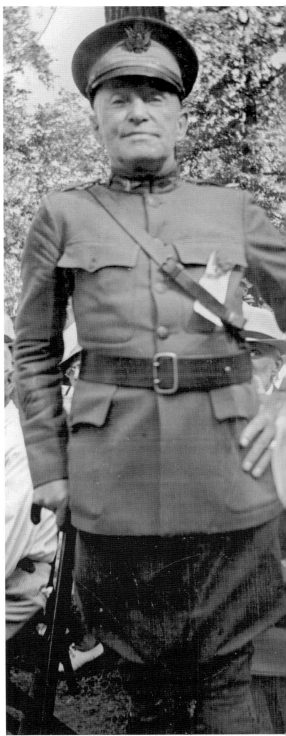

Augustus H. Gansser Astride His Horse "Logan," c. 1898
Captain Gansser was given the task of correspondent for the *Detroit Tribune, Muskegon Chronicle, Detroit News, Bay City Times,* and *Bay City Freie Presse* during his time in Cuba. He spent much of that time in the area around Santiago and San Juan Hill, including a 10-day special detail protecting the extreme right flank of the American Army by clearing the San Juan Valley of guerilla fighters.

Lt. Col. Augustus H. Gansser, 1933
By the late 1930s "Colonel Gus," as he had affectionately come to be known, had virtually retired from public life. He died April 25, 1951, at the age of 78 as a result of a long illness. He was buried in the American Legion Veterans Section of Oak Ridge Cemetery on Bay City's west side near many of the comrades with whom he once served.

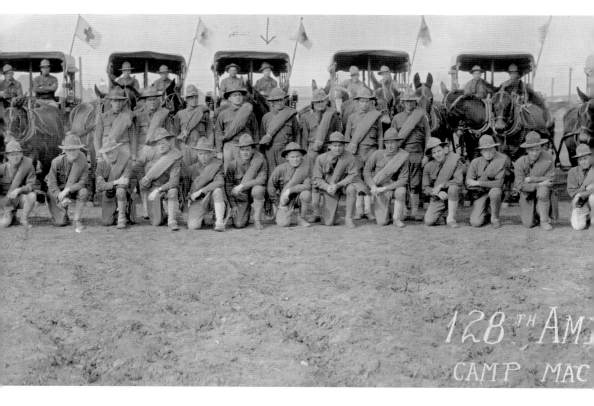

Members of the 128th Ambulance Gather at Waco, Texas, 1917
The Bay City Hospital Corps was organized July 1, 1904 with one captain, medical corps, and 13 enlisted men. Their early service was spent during several statewide incidents including the 1911 Oscoda area fire, and the 1912 Calumet Copper Strike. In 1915, they were organized as the 2nd Michigan Ambulance Corps. Dr. M.R. Slattery joined the corps in 1916 when orders came to mobilize the company for the Mexican Border campaign. The 2nd Michigan Ambulance, now 150 men strong, was called to duty in the American Expeditionary Forces (AEF) on August 15, 1917, and reported to Camp Grayling to await further orders. Later, upon arrival at Camp MacArthur in Waco, Texas, they were attached to the 107th Sanitary Train and redesignated the 128th Ambulance Company. Their ambulances were mule-pulled wagons, thus much of their time was spent on animal detail as well as the customary training maneuvers. They left on February 8, 1918, and then boarded the vessel *Susquehanna* for St. Nazaire, France, where they arrived on March 10, 1918. The company slowly made their way to the battlefront in northeastern France. Their duties included setting up wound dressing stations, evacuating the wounded to their ambulances, and general first aid. They made their way through France via train, truck, ambulance, and on foot. On August 7, 1918, Ed Donoghue and Fred Doyle were the first to locate Quentin Roosevelt's grave outside of Cierges. Roosevelt was the son of Pres. Theodore "Teddy" Roosevelt and as a military pilot had been shot down in an aerial battle on July 14 and buried by the Germans. On August 29, 1918, Pvt. John Olk was killed and Sgts. Carl Smith, Ben Zielinski, and Erwin Carl were all wounded when a shell exploded in their midst while loading a wounded serviceman into their ambulance after a risky rescue from "no-man's-land." After the war, the 128th became part of the Army of Occupation from November 20, 1918 to April 21, 1919. They received 12 motor ambulances on November 16, 1918, for use during the occupation campaign; they were disbanded after World War I.

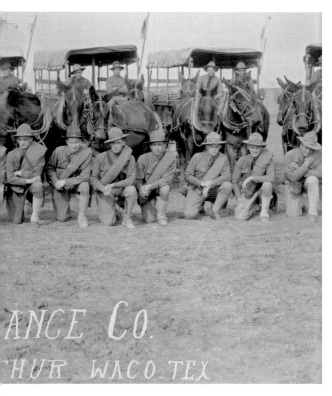

ANCE CO.

HUR WACO TEX

Matthew R. Slattery, 1st Sgt. Adolph G. Bickel, and Capt. Edward C. Smith (ABOVE RIGHT)
Captain Slattery, a veteran of the 128th, was the commanding officer of the 121st from 1930 to 1940. Slattery was on staff at Bay City's Mercy Hospital. Sergeant Bickel was a barber by trade and the "mule and motor" officer during World War I; he later helped form the 121st. Pvt. Edward C. Smith was a patternmaker by trade who served with the 128th in Europe and was later appointed 1st lieutenant of the reformed 121st in 1930 and captain in 1932. Slattery, Bickel, and Smith are pictured with the 121st Ambulance around 1930.

Bill Widmer (left) and Stanley J. Gregory (right) in France During World War I (RIGHT)
Private Gregory was with the 2nd Michigan Ambulance when they left for Waco prior to becoming the 128th and crossing the Atlantic for service in Europe. While in France, Private Gregory and his comrade, Pvt. Bill Widmer, were separated from the 128th and reassigned to another company near Paris. Both men returned home with the 128th. Gregory was the son of Chauncey (Chan) Gregory of the C & J Gregory Printers, bookbinders and stationers of Bay City.

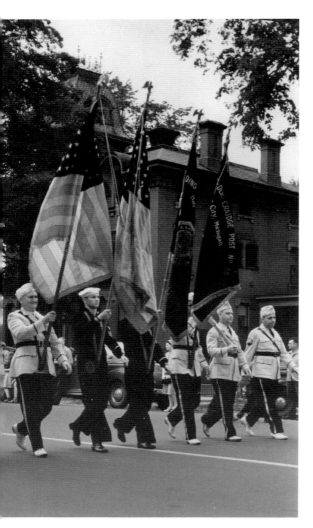

American Legion Color Guard in Parade, c. 1940

The American Legion was founded in Paris in 1919 by members of the American Expeditionary Force (World War I) as a patriotic, mutual-help, wartime veterans' organization to preserve the memories and incidents of their associations in the great wars, among other things. Pvt. John Olk (killed in action with the 128th Ambulance) was memorialized by the war veterans of his Bay City hometown when they named the Harding-Olk-Craidge American Legion Post 18 in memory of Olk and two other fallen heroes in 1919.

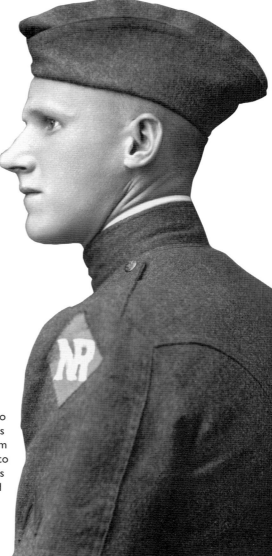

John F. Mieloch, 1918

Mieloch was a baker and a laborer in Bay City prior to his service in the 339th Infantry, Company G, known as the "Polar Bears," who served in northern Russia from September of 1918 until June 1919. Their mission was to secure the area from the Bolsheviks. Bay County was represented by almost 100 men like Mieloch who faced bitter cold and poor housing, food, and sanitation.

Carl H. Smith, Mrs. Frank Vallaire, and Vera Lutren of the Blue Star Mothers, c. 1950
Smith (left) was a decorated veteran of the 128th Michigan Ambulance Company during World War I, who was wounded and lost an arm as a result during his time in Europe. After the war, he became a prominent Bay City attorney and was involved in the community as well as with the American Legion of Michigan, for which he was a past state commander. The Bay City Chapter of Blue Star Mothers (#11) was chartered in September of 1942. Lutren (right) was a charter member who served the organization for many years. The Blue Star Mothers, open to mothers of all veterans, was created as a support organization for stateside veterans, providing services such as visiting the local Veterans Administration (VA) hospitals to provide companionship and personal care items for those in need.

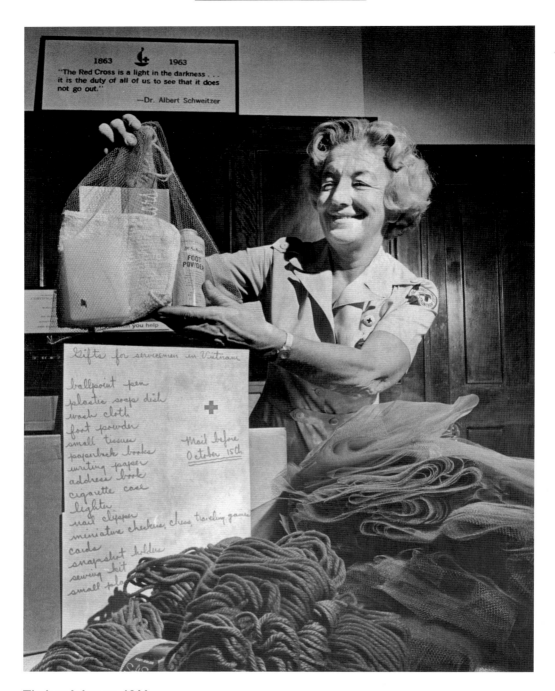

Thelma Johnson, 1966

Johnson, a volunteer with the Red Cross, is shown packaging items to be sent to soldiers fighting in the Vietnam War in September of 1966. Though not considered a veterans' organization, the American Red Cross has helped countless servicemen and women through their efforts. Their services, provided mostly by millions of volunteers throughout the world, include humanitarian aid of all kinds.

CHAPTER FOUR

Business and Industry

We cannot depend upon our lumbering interests to keep up the city, much less contribute to its future growth. Neither will the farming interests, though excellent, support a city of larger growth than we have already made, while the limited number of permanent industries are altogether too few to insure the growth desired.
(*Bay City Tribune*, 1/1/1894)

As early as the 1890s, speculation about the viability of the lumbering industry had a few enterprising locals worried about the economic future of Bay City should something change. Most people never believed that within a few short years the major economic driver that was the lumber industry would be gone to greener pastures. Businesses founded by men like Charles Jennison, C.S. Ford, and John Arnold would survive in the post-lumbering era and go on to see several generations become successful. Capt. James Davidson started the first round of successful mega-shipbuilding interests, which would be followed in the post-consolidation era by the highly successful Defoe Shipbuilding Company, started by Harry J. Defoe. Just like James Davidson's son James E. would go on to become successful in the shipping and banking industries, Harry Defoe's sons Thomas and William took their father's shipbuilding company to additional years of success. Other businesses were either founded or reinvented themselves after lumber left. Otto and William Sovereign started the highly successful Aladdin Homes Company to manufacture and sell pre-cut housing; the company became pioneers in this industry that dominated the 20th century. Charles Coryell and Henry Vallez became leaders in the sugar production industry. Harman and Verner and Pratt and Koeppe were firms that were leaders in their fields. Carl Gladen became highly successful and influential in the production of plastics and plastic toys. Les Staudacher's race boat–building skills were sought by many. William Clements, Charles Wells, Ben Boutell, Henry B. Smith, W.D. Young, and Peg and Paul Rowley all were highly successful in business and gave much back to the local community through their leadership and philanthropy.

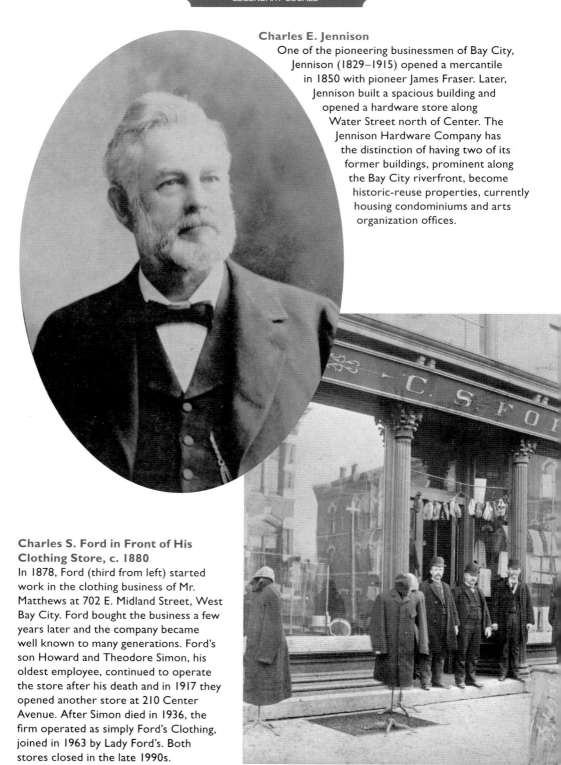

Charles E. Jennison
One of the pioneering businessmen of Bay City, Jennison (1829–1915) opened a mercantile in 1850 with pioneer James Fraser. Later, Jennison built a spacious building and opened a hardware store along Water Street north of Center. The Jennison Hardware Company has the distinction of having two of its former buildings, prominent along the Bay City riverfront, become historic-reuse properties, currently housing condominiums and arts organization offices.

Charles S. Ford in Front of His Clothing Store, c. 1880
In 1878, Ford (third from left) started work in the clothing business of Mr. Matthews at 702 E. Midland Street, West Bay City. Ford bought the business a few years later and the company became well known to many generations. Ford's son Howard and Theodore Simon, his oldest employee, continued to operate the store after his death and in 1917 they opened another store at 210 Center Avenue. After Simon died in 1936, the firm operated as simply Ford's Clothing, joined in 1963 by Lady Ford's. Both stores closed in the late 1990s.

Stanley F. Northcott, c. 1925
In the mid-1920s Northcott (1895–1975) established WSKC, the first radio station in Bay City, and was the first station engineer. At the time, there were only 750 radio stations in the entire country. It was broadcast from coast to coast and from Central America to northern Canada (pre-FCC). James E. Davidson bought WSKC in 1928 and renamed it WBCM (after Bay City, Michigan), with Northcott as manager. From the early 1930s to 1968, the studios were in the Wenonah Hotel.

John G. Arnold, Arnold's Bakery, c. 1905
Started in 1856 by German immigrant Frederick G. Arnold, Arnold's Bakery would become a well-known fixture at 5th and Saginaw Streets for many generations of local residents. Son John G. Arnold (at back, right) took over the business in 1892, passing it to his four sons in 1932. In 1981, the Historical Society of Michigan recognized the company as Michigan's oldest active bakery after 125 years (and four family generations) in business. They closed in the early 1980s.

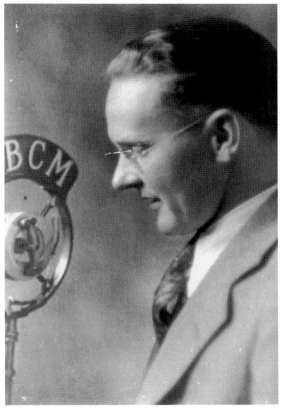

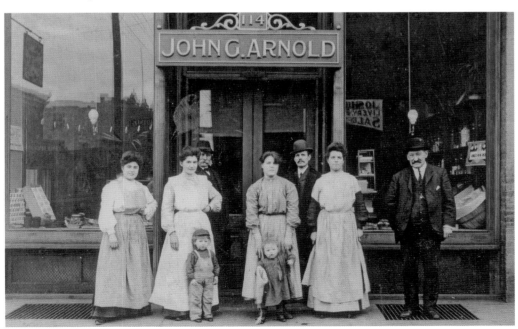

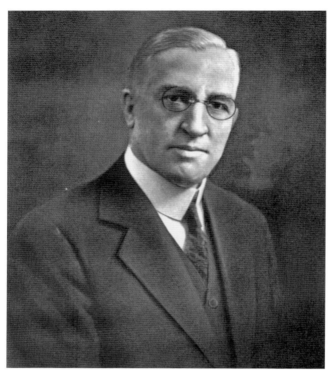

James E. Davidson
Like his father, Davidson (1867–1947), chiefly known for his work in the shipbuilding industry, was also involved in many other interests including sugar production, finance and banking, education, politics, athletics, and freemasonry. In 1931, he prevented the collapse of the city's only remaining bank, Peoples Commercial (of which he was president), by flying in a million dollars of his own money as a guarantee for depositors. Later the bank loaned the school board money to pay salaries to keep the schools open.

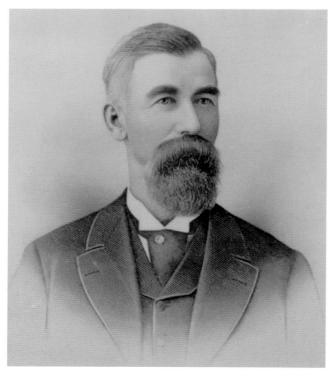

Capt. James Davidson
Captain Davidson (1841–1929) moved his shipyard to Bay City in 1871. During the next 32 years, the vessel captain, shipbuilder, and businessman created a "wooden Great Lakes empire" that included the largest wooden vessels built on the Great Lakes, a profitable fleet of vessels, and personal wealth and influence throughout Bay City and the entire Great Lakes region.

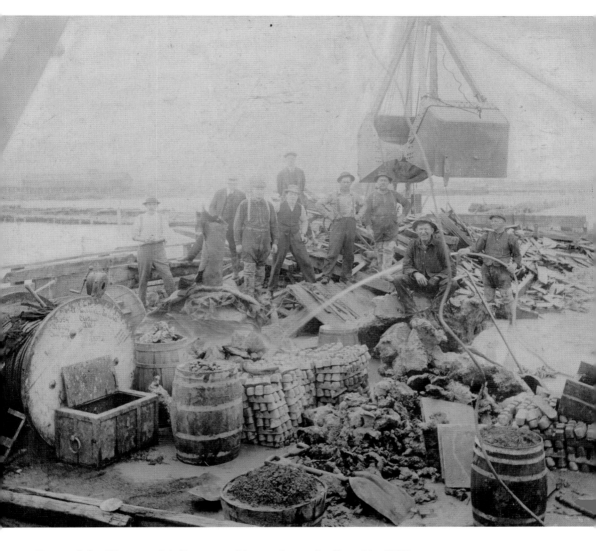

Crew of the *Eleanor* with Recovered Items from the *Pewabic*, 1917

The barge *Eleanor*, owned by W.J. Meagher and Sons, Inc. of Bay City, provided the platform for one of the most ambitious salvage attempts in Great Lakes history. The *Pewabic*, known as the "Death Ship of Lake Huron" because so many lives were lost, sank in Lake Huron off Thunder Bay in 1865 after a collision with her sister ship the *Meteor*. The ship, loaded with many tons of copper, was now resting 180 feet below the lake's surface and considered very dangerous to salvage at those depths. Several attempts were made without success. In 1917, with the great need for copper due to World War I, Meagher's services were contracted to a group out of Detroit in an attempt to salvage the precious cargo. The expedition was a success as the group was able to retrieve many tons of copper.

Harry J. Defoe

Defoe (1875–1957) was the managing partner of Defoe Boat and Motor Works (later Defoe Shipbuilding Company). In 1905, the former school principal started the small knock-down boat business that rapidly turned into one of the largest shipyards on the Lakes. He was also the first president and director of National Bank of Bay City and a director of Bay City Boats, Incorporated, and was involved in many community ventures.

Lenore at the Defoe Yard, 1931

The *Lenore* was originally built at Defoe Boat and Motor Works in 1931 for Sewell Avery, the chairman of Montgomery Ward. This 92-foot wooden yacht was used by the Navy in World War II and later assigned as the presidential yacht in 1956. It served presidents Eisenhower (as the *Barbara Ann*), Kennedy (as the *Honey Fitz*), and Nixon (as the *Patricia*).

Thomas and William Defoe
After their father's death in 1957, Thomas (second from left) and William (second from right) managed the shipyard. The company would never again attain their wartime record of 154 vessels built in six years, though government and private contracts sustained them until the early 1970s, building four guided missile destroyers, two lake freighters, three special destroyers (for the Australian navy), five research vessels, and some smaller craft before the yard closed in 1976. Thomas and William are pictured with US Navy personnel in front of a completed guided missile destroyer in 1961.

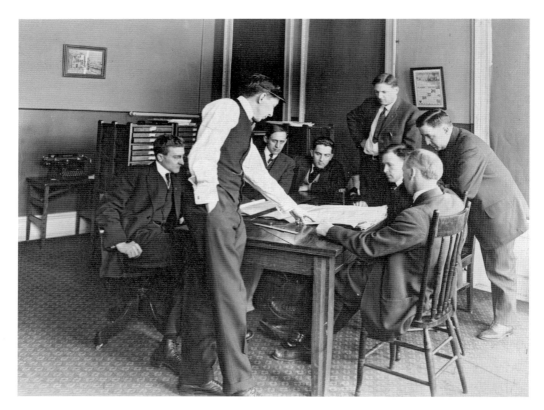

Aladdin Homes

Aladdin's "famous board of seven" was the early company leadership. Otto Sovereign is standing in the foreground and William Sovereign is seated at right. "Every house shown in the Aladdin catalog is erected in Bay City, with two or three exceptions," read the 1918 Aladdin Homes Catalog. "You will find whole streets of Aladdin Houses, whole subdivisions on which only Aladdin Houses are erected. Bay City is truly called Aladdin Town, and Bay City people seem very proud of it." Established in 1906, by brothers William and Otto Sovereign, Aladdin is credited as the pioneer in the manufactured housing industry for creating a standardized system of construction that reduced building costs without sacrificing architectural style. Aladdin is also noted for their contributions to the mail-order housing industry by creating the first catalogs that would eventually end up in millions of mailboxes worldwide. Their final catalog was in 1983; after 76 years in business the company had produced over 100,000 homes.

Aladdin Advertisement
This original seven-line advertisement was featured in the *Saturday Evening Post* in 1909.

Harman and Verner Studio

Harman and Verner were the most prolific professional photographers in Bay City. Most Bay City families from their era have at least a few family photographs bearing their distinctive script mark. George A. Harman and James C. Verner started in Bay City in 1875. Their studio moved several times until settling at the corner of 4th and Washington in 1889 (pictured) in an elaborate tall and narrow building designed and built for them by local architect Phillip Floeter. Their elaborate cabinet card photographs featured not only an eye-catching name plate on the front, but also an elaborate artist rendering of this new building on the back with a listing of the types of photographs they offered. They were in business until around 1910. James Harman continued in business by himself until 1916.

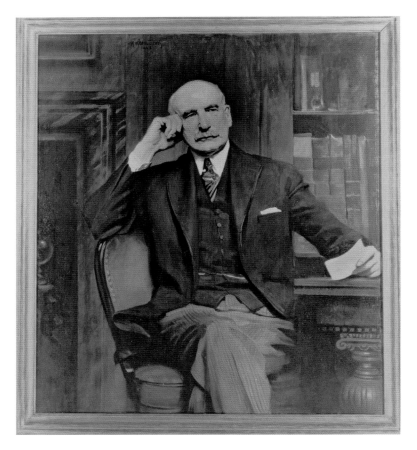

William L. Clements

Clements (1862–1934), an Ann Arbor native, would become one of Bay City's most notable residents and ultimately leave a large legacy in the town he called home for much of his life. He joined the staff of his father's company, Industrial Works (IW), as chief mechanical engineer in 1882. W.L. Clements had a background in engineering from the University of Michigan. He would become one of the major figures in shaping the future of Industrial Works, and in the process he would leave his mark on Bay City. He was also a president of the First National and Bay County banks. He also donated the land for the James Clements Airport, in honor of his son, James Renville, who gave his life serving his country during World War I while in the US Army Signal Corps. W.L. Clements spent much of his fortune amassing a large collection of historic papers, books, and maps, which would become the foundation for the renowned Clements Library on the campus of the University of Michigan. He described his efforts in a short biographical sketch. "As early as 1893, the formation of a library on the subject of American History was commenced, and with increased financial resources the desires of the book collector were more or less satisfied. With such satisfaction and with an earnest desire that the historical library formed should be of benefit to research workers in American history, he decided, in 1920, to give to the University of Michigan this rather extensive library upon the specific subject of American history, also to erect a proper building for receiving it. Accordingly, this was done with the full approval of the Board of Regents of the University of Michigan, and in the summer of 1922 the building was presented to the University and formally dedicated. . . . A general resume of the library has been written in the form of a book entitled, *The William L. Clements Library at the University of Michigan*." Clements served many years on the Board of Regents of the University of Michigan.

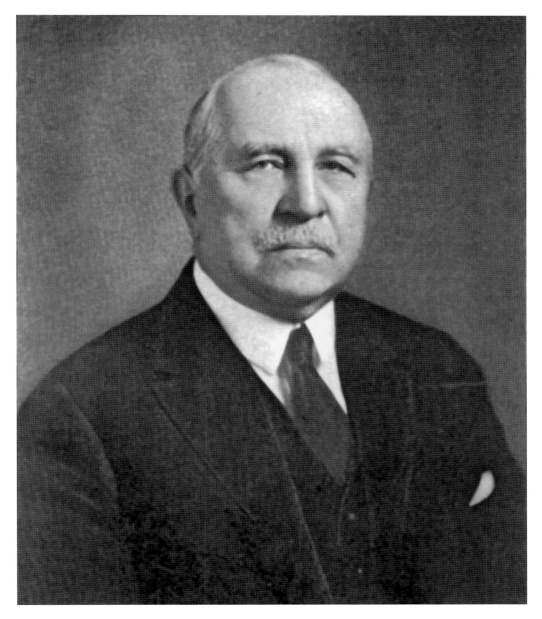

Charles Russell Wells.

Wells (1852–1928) came to Bay City and started with Industrial Works in 1873 as secretary, and in 1882 he also took over the duties of treasurer upon the passing of his father Ebenezer. He continued with IW for 51 years until 1924. In addition to IW, Mr. Wells was involved in such Bay City enterprises as the Gas Light Company, the Bay City Street Railway Company, the First National Bank, and the Bay County Savings Bank. He was also local chairman of the Red Cross, the Liberty Loan campaign of World War I, and a member of the BPOE Lodge 88 and Bay City Rotary Club. He was an avid boater and had amassed a large library. He built a spacious home at 2229 Center Avenue (torn down in 1946) where he lived until his death.

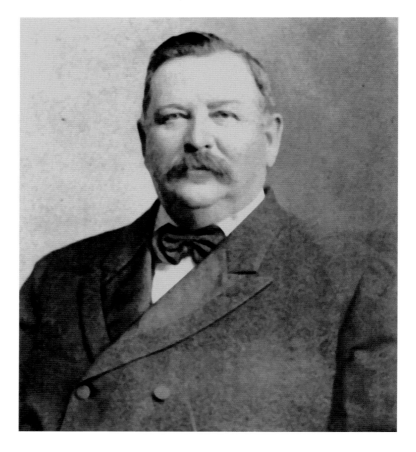

Capt. Benjamin Boutell

"During his 39 years of activity in this business, Captain Boutell is credited with handling more timber than any other known man in this country." (Augustus Gansser, 1905)

Boutell (1844–1912) moved to Bay City in 1859 and in 1867 he became the captain of the steamer *Ajax* and in 1868 of the steamer *Reynolds*. In 1869, he became captain of the tug *Union* and entered into a partnership with Capt. William Mitchell. Mitchell and Boutell would be the first of many partnerships that would ultimately lead Captain Boutell to become a very well respected, revered, and wealthy businessman. He was able to take advantage of the enormous growth Bay City was experiencing as a booming lumber town and harness that energy to make his own fortune.

Some of the other enterprises in which Captain Boutell engaged included the Marine Iron Company of Bay City in 1899, The Boutell Transit Company of Bay City (1891), Boutell Towing and Wrecking Company of Sarnia, Canada (1895), Hampton Transit Company (1896), Boutell Towing and Transit Company of Boston, Massachusetts (1899), and Boutell Steel Barge Company (1905). He also established sons William and Frederick and nephew Lorenzo in Boutell Bros. Coal Company in 1896. In addition, he was also involved in the Pacific Portland Cement Company, West Bay City Sugar Company, Michigan Chemical Company, Bay City Sugar Company, Michigan Sugar Company, Excelsior Foundry of West Bay City, Craig Foundry of Toledo, Ohio, several large farms in the area, and various coal fields in Bay County. A large man, he was often mistaken for Pres. William Howard Taft, with whom he shared a striking resemblance. Complications from an unfortunate accident that happened while running to catch a train in 1912 cut his life of prosperity short.

Saginaw Bay Towing Association Advertisement, 1896

In 1888, Capt. Benjamin Boutell entered into a partnership with Capt. Peter C. Smith. Called the Saginaw Bay Towing Association, their primary business was to tow rafts of cut logs for the mills. They were reputed to have towed the most logs ever on the Great Lakes during their years in business. Boutell bought out Smith's company share in 1900.

William and "Benny" Boutell, c. 1900

"If he saw any kind of opportunity to make it work, he would make it work." (William Boutell, Great-Grandson)

Capt. Benjamin Boutell's legacy was a family that had that same "can-do" attitude. Successive generations from son William to grandson "Benny" and beyond have been involved with many successful ventures over the years.

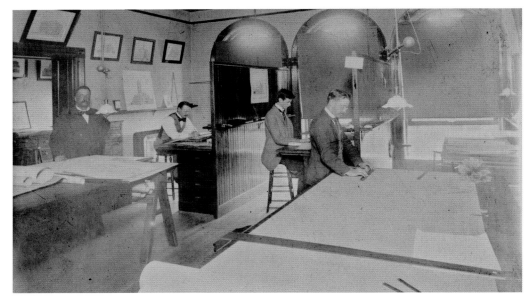

Leverett A. Pratt and Walter Koeppe in the Drafting Room, May 8, 1895
Architects Pratt (left, 1849–1924) and Koeppe (second from left, 1855–1912) formed the firm of Pratt and Koeppe in 1880, and the wide range of styles and buildings they designed and their excellent professional reputation helped them quickly become one of Bay City's most successful architectural firms. They designed some of Bay City's most famous and fondly remembered buildings, including city hall and the National Guard Armory (now Historical Museum), and numerous churches, business blocks, and homes that are still around today, a testament to their excellent design work. Koeppe retired to his native Germany in 1910 and in 1912 Pratt formed the firm of Pratt, Bickel and Campbell with Robert Bickel and Felix Campbell. Pratt retired in 1916 and lived for a time at the Anson Apartments (pictured below in 1917), a building at 1414 Center Avenue that the firm designed in 1916 as a "modern" departure from the heavy Victorian influences for which Pratt and Koeppe were well known.

Henry Vallez in 1939
Vallez (at left, 1871–1964) was called the "dean of the sugar beet industry" by many in the field. He came to the United States from France in 1890 and to Bay City in 1901, where he took a job with the German-American Sugar Company in 1903. That company later became the Monitor Sugar Company. As superintendent, Vallez was instrumental in developing techniques and practices that made the plant a success.

Charles A. Coryell Sr.
Coryell had a long and notable career in the sugar beet industry and was one of the founders of the Farmers and Manufacturers Beet Sugar Association. He spent 15 years as president of that organization and was involved in fostering national sugar beet legislation. He started with Monitor Sugar Company when it was acquired by his family's corporation in 1932. Here Coryell receives an award for distinguished service to agriculture from MSU president Clifton R. Wharton Jr. in 1973.

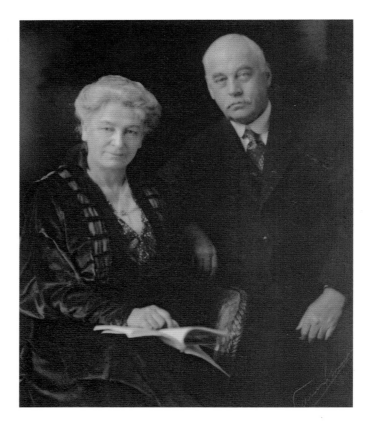

Henry B. and Mary H. Smith

Henry Bloomfield Smith (1848–1920) was born in Canada to Christina (Long) and Henry P. Smith, a successful New York lumberman who owned pinelands in northern Michigan. Smith came to Bay City to manage his father's interests in 1881 where he married Mary S. Hill (1855–1938), on February 24, 1881. His first local business venture was managing the Michigan Pipe Company, followed by the National Bicycle Company and Natco Truck plant. National Bicycles was considered one of the finest brands in the nation and the slogan, "A National Rider never leaves his mount," was testament to the customer loyalty toward the brand. The plant was later enlarged to help with the manufacture of the Natco truck, of which the company only made 14 before the plant was sold to the General Motors Corporation where it was used in the manufacture of parts for Chevrolet automobiles. General Motors is regarded highly among Bay City's major employers to this day. Among Smith's other interests were lumber companies in Michigan and Canada, and positions with the Dominion Sugar Company of Canada; World's Star Knitting Mills; First National Bank; Bancroft, Romer & Co. (dry goods); and waterworks companies in Colorado and Ohio. He amassed a fortune while still looking out for the welfare of his employees, something for which he was fondly remembered. In 1906, a steel Great Lakes freighter bearing the name *H.B. Smith* in his honor was built at the American Shipbuilding Company in Lorain, Ohio. That vessel was lost on Lake Superior with all hands in the infamous November 1913 "King of Storms." Smith was a practicing Mason, a member of the First Presbyterian Church, and affiliated with many local charities and clubs. His local philanthropy included the Bay City Memorial Hospital and other community projects. Mary Hill Smith was an early graduate of Vassar College (1879) and remained very active in the local community. She was instrumental in the early formation of the Bay County Historical Society for which she collected many items from local residents that were later donated to the museum for safekeeping, as did several generations of Smith relatives. H.B. and Mary Smith had six sons.

Peg and Paul Rowley, 2011

"Paul and Peg Rowley have been an integral part of building the Arts and Culture to what it is today. . . . From Studio 23, The Bay Arts Council, to the International award winning Historic State Theatre . . . with their love of the Arts and Culture, and drive to make things succeed, they are a big part of why things continue to flourish in Bay City." (Mike Bacigalupo, State Theatre, Bay City)

In 1991, Peg and Paul Rowley were inducted into the Bay Area Chamber of Commerce's Hall of Fame for their many contributions to the Bay Area. Peg Rowley has been instrumental in many arts and culture projects that include the Rriverwalk along the riverfront, the Riverwalk pier, the Bay Music Foundation, as a founder of the Bay Concert Band, the world Friendship Shell, and as a driving force behind the formation of the Bay Area Community Foundation. She also had leadership roles in the Bay City Fireworks Festival, the Friendship Shell, the summer concert series, Jennison Nature Center, and Tobico Marsh Interpretive Area. Mrs. Rowley, a graduate of Bay City Central, is an accomplished violinist who has performed with the Saginaw and Midland symphonies and has been an advocate of scholarships for students who specialize in music. Paul Rowley was an early and longstanding member of Delta College's board of trustees, a president of the Bay City School Board, and a board member of the Society for Crippled Children and Adults. He was recently lauded as a "tireless advocate for Bay City," most recently as a board member of Rivers Edge Development Corporation, which is responsible for leading the development of the Uptown at Rivers Edge property. Both Rowleys have been involved in projects that include the Jennison Place condominiums, which is an adaptive reuse of a historic hardware building, the Infinity Skate Park on Marquette Avenue, and the State Theatre. The couple, who have been married for over 60 years, are also involved with several family enterprises, including Rowleys Wholesale, run by several generations of Rowleys. (Courtesy of Mike Rowley.)

Carl and Audrey Gladen

Carl Gladen (1916–2010) was an early pilot and flight instructor who had a background in welding and aircraft repair. Necessity led him down the path of toy manufacturing. In 1960, he saw an article about Moulton Taylor's flying automobile, dubbed the "Aerocar," and he contacted Taylor about making a "toy" version. Gladen signed an agreement to produce and distribute the toy Aerocar, which got a boost when actor Bob Cummings started featuring the model on his television show in 1962. Gladen then became the regional distributor for the actual Aerocar in Michigan, bringing one to Bay City to demonstrate in hopes of garnering orders. Unfortunately Aerocar International did not receive enough orders nationally to warrant starting production, and the concept was shelved. Carl and Audrey are pictured with the Aerocar at James Clements Airport in 1961.

Carl and Audrey with Their Plastic Toys
Carl Gladen produced and sold his own ideas for plastic, futuristic-looking toys. Carl and Audrey founded Gladen Enterprises in 1951 and set about manufacturing, marketing, and selling items like the new plastic machine gun, plastic gliders, rocket launchers, and many other unique toys. They are pictured next to a Kresge store display with some of their plastic toys in 1951.

Carl with a Gladen Enterprises Trade Show Display, c. 1970
In 1968, Carl Gladen developed several techniques and processes that helped advance hot stamp decorating, and by 1969 Gladen Enterprises was the leading supplier of silicone sheet, dies, and rollers. The company merged with Hayes Corporation and Gladen retired in 1974 to spend more time on his hobbies of boating and flying.

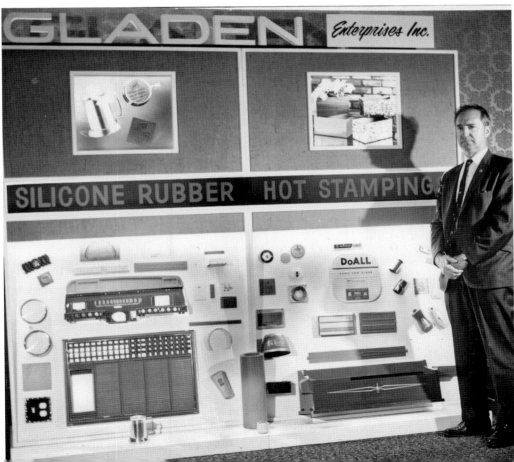

Caricature of Walter Dickerson Young, c. 1900

Young (1855–1916) started work as a clerk at the Bay City Bank, which was owned by his father. He then took charge of the Bay City Brewing Company, and later had interests in many other ventures including the coal, wood, and ice trade; Reid Towing and Wrecking Company; and the German-American Sugar Company. He is probably best known for the W.D. Young and Company, the largest manufacturers of hardwood flooring in the United States.

WALTER D. YOUNG
BAY CITY
LUMBER AND FLOORING
W. D. YOUNG & CO.

Les Staudacher

Staudacher built world-class unlimited class hydroplanes in his Kawkawlin shop from 1948 until the 1970s. One of his regular clients and friends was Guy Lombardo, the famous bandleader. He would regularly conduct test runs on the Saginaw River or nearby waterways. Here he pilots one of his creations in the Saginaw River with an open Veterans Bridge in the background in 1967.

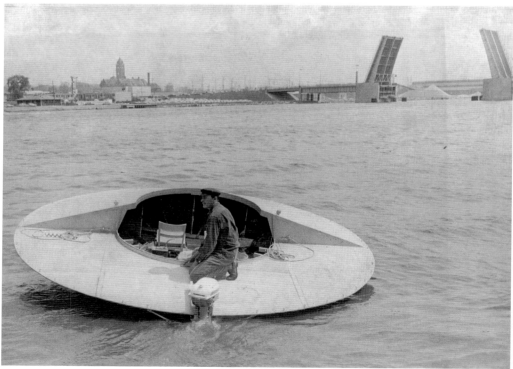

CHAPTER FIVE

Musicians, Entertainers, and Artists

The year 2011 was a particularly sad year in Bay City for music, arts, and entertainment. The community lost several well-known and highly admired musicians and entertainers all in the prime of their careers or avocations. Maestro Leo Najar, founder of the Bijou Orchestra and highly regarded throughout the region for his work in orchestral music and with the arts in general, was the year's most public loss. Equally as devastating to the music scene, though not as highly publicized, was the loss of Jerry Marcet, who had played bass and guitar with many bands over a long career in the local music scene. Both deaths were sudden and unexpected, both men were of the same age, both were actively collaborating with others throughout the region, and each, in his own way, was a local legend. Maestro Najar and Marcet were modern-day representatives of the many local musicians, artists, and entertainers who have called Bay City home over the years. Lionell "Nello" DeRemer—pilot, showman, musician, entertainer, mentor, and community icon—helped put Bay City on the map with his early orchestra work, barnstorming, and later at WBCM radio and with Spotlight on Youth. Annie Edson Taylor rode her custom-made barrel over Niagara Falls, becoming the first person to do so and survive. Dolores Vallecita shared the world's stages with her trained animals. Charles White created a music program in Bay City Public Schools that continues to teach scores of eager young minds how to hone their musical skills. To Harry Jarkey and Bob Bloenk, laughter is the best medicine. Hairdresser Art Schiell's hobby turned out a number-one hit for a local band, while over a decade later, the Burdons did it themselves and are still doing it to this day. "Miss Pat" Ankney brought the grand scale of musicals to local schools, while the Bay City Players are distinguished among Michigan's amateur theaters. Finally, sculptor Rita Greve and poet Irene Warsaw, contemporaries who admired each other's work, both shared a common bond with their love of poetry.

Lionell "Nello" DeRemer

"Wings came early to Musical Director and Announcer Lionell DeRemer. No, he wouldn't imply that he is any kind of an angel, any more than he would claim to be younger than 52 years, but he was the 115th person licensed to fly an airplane in this country. . . . And as if that were not enough, he became a widely recognized piano impresario . . . which brings us to his radio advent: In the autumn of 1928, 'Nello' (from Lionell, we suppose) came back to northeastern Michigan after years of all kinds of musical performances throughout the country. WBCM needed a pianist, 'Nello' stayed. He is the veteran in our staff." (Excerpt from a WBCM promotional booklet)

Lionell "Nello" DeRemer (1889–1962) had a natural talent in music and became an accomplished pianist by his teenage years. One of his first musical ventures was a small movie house in Bay City, where he provided the musical accompaniment for the silent films. He also played in several small traveling orchestras. DeRemer took an early interest in the newly emerging field of aviation and took lessons at the Beatty School in New York. He soloed after only two and a half hours of instruction and on April 19, 1912, was granted aviation license #115 for his efforts. Nello then purchased a Wright Model B (#15) from the Wright Company and commenced flying exhibitions at fairs throughout the Midwest. Airplane exhibitions, dubbed "barnstorming," were very popular. He then formed the DeRemer Aviation Company, with his father, M.C. DeRemer, as manager. DeRemer and his "flying machine" were local attractions for the next few years. On August 2, 1914, Nello was flying solo after taking off from Wenona Beach when the motor caught fire in the air. He was able to bring the plane down in the Saginaw River and swim to shore; however the plane was a total loss. This accident ended DeRemer's flying. In the 1930s, DeRemer went to work for WBCM as an announcer and director of musical programs, and retired in 1958 after an illustrious career. He was posthumously honored as an "Early Bird" of aviation by the Smithsonian Institution in 1962.

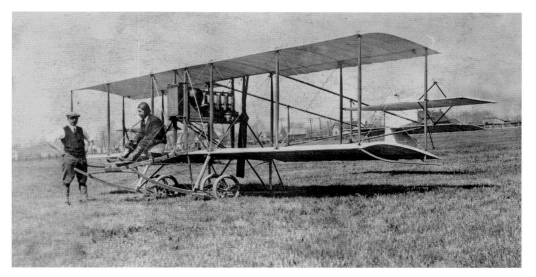

Lionell DeRemer Tests a Brooks Airplane, 1912
DeRemer took a temporary position with the Brooks Company in Saginaw as a test pilot for an airplane they were producing. The Brooks Company was started as Brooks Boat Company by Clifford Brooks in Bay City and produced "knock-down" boats. Brooks moved to Saginaw a few years later and diversified the company by adding furniture and airplanes to their product line.

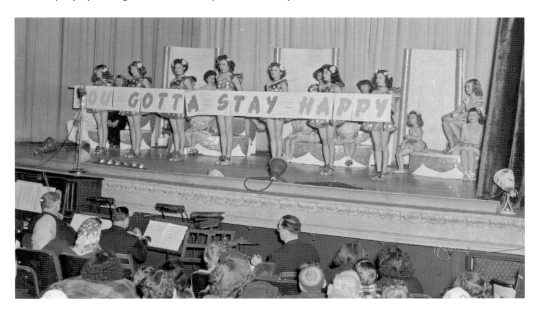

Theatrical Arts Guild Performance
In addition to his duties at WBCM, DeRemer also found time to assemble and manage several groups of local young entertainers, including the Theatrical Arts Guild and the Jolly Bunch. Under Nello's direction, many talented local young people got their start in singing, dancing, and acting through the variety shows that were offered locally and throughout the state, including one prestigious show at the Grand Hotel on Mackinac Island.

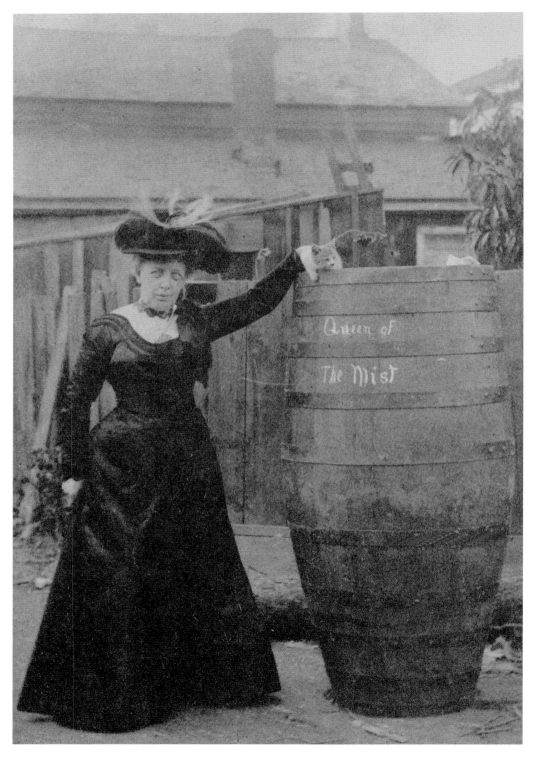

Queen of the Mist (LEFT)

The Horseshoe Falls at Niagara Falls had previously claimed many victims; however that did not dissuade Bay City dance teacher Annie Edson Taylor (1838–1921) from attempting to be the first person to survive the ride over the falls in a barrel. Mrs. Taylor's barrel was strongly built to her specifications by a West Bay City cooperage and it served her well. Her October 24, 1901, trip over the falls only dealt her a gash and a slight concussion for her efforts, and it earned her status as the first person to survive such a trip. However, due to a series of dealings with unscrupulous managers, she was never able to turn her ride into the financial success she wanted and died penniless in New York State in 1921.

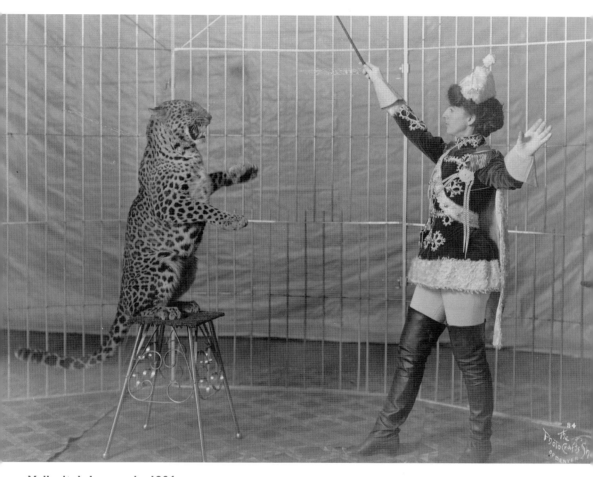

Vallecita's Leopards, 1906

Dolly V. Hill, known by the stage name Dolores Vallecita, was an internationally known animal trainer who traveled the world's vaudeville circuits with her animal acts, which included trained dogs, pumas, and Indian leopards. She settled for a time in Bay City where she had a training studio at 814 Saginaw Street. She was a passionate believer in the humane treatment of animals and did not allow guns to be used around the animals. Tragically, while training her six leopards in Bay City, one of the animals jumped at her and severed her windpipe with one of its claws. She was rushed to Mercy Hospital where she was attended by doctors M.R. Slattery and R.N. Sherman. Unfortunately, their efforts proved unsuccessful as she passed away at age 42 and was buried in Elm Lawn Cemetery on January 15, 1925. It was said she had been an animal trainer for more than 25 years. (Courtesy Library of Congress.)

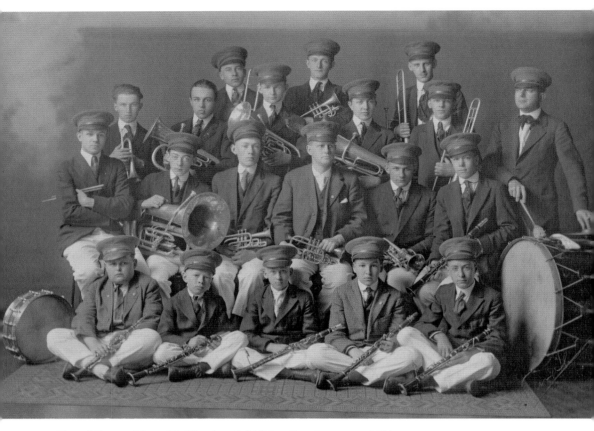

First "Central Band," Charles H. White Conductor, c. 1921

This was one of the first bands organized in Bay City by White (1876–1949, center row, third from right), who was Bay City Public Schools' superintendent of music programs. A testimonial dinner in his honor was held in 1939 by the Harding-Olk-Craidge Post 18, American Legion; the following is excerpted from their salute: "Music and Charles White are old friends. And it's small wonder that this is so. Over in Marden, Kent, England, his birthplace he was choir boy at the age of eight, an organist in Parish Church at 13. . . . Across the Atlantic he came in 1899 . . . It was in 1903 that he began his 36 years of musical service with Bay City's Trinity Episcopal Church. Active in the Thursday Morning Musicale Club, organizer of the Choral Union Mr. White was also a member of the Bay City Symphony. For 26 years he was the private organist for the Late William L. Clements. For 35 years he has had charge of music at the Consistory and for it once broadcast a series of 24 recitals. Member of Rotary Club, he has been its pianist for 24 years. Turn back to 1916 . . . It was then he became supervisor of music in Bay City public schools. Starting from scratch—there had been very little vocal music in the schools, no instrumental music at all—first year's efforts yielded band of sorts and 16 pieces, a mixture of pupils and teachers. But here was laid the foundation of what is today Bay City's highly reputable school music program. The Sunday afternoon war-time concerts in the Armory originated with Mr. White. So did 1917's five day exhibit of all branches of work done in public schools which attracted thousands of people . . . since then, who has not thrilled to the stirring airs of Central High School's Band? Who has not marveled at the renditions of the All-City-Grade School Orchestra or the Boys' and Girls' Glee Club? Particularly when one considers that many of these youngsters, some of them hardly large enough to hold up an instrument, might not otherwise have had an opportunity to study and learn music and thus broaden their education and enrich their lives."

Bob Bloenk in Action, c. 1966
Modern-day vaudeville would best describe Bob Bloenk's variety act (center, with guitar). He started in the "business" over 70 years ago at a very young age; whether it was dancing, singing, or playing the ukulele or guitar, the retired school administrator (Handy and Western) found the allure of showbiz something irresistible and addicting. He has entertained throughout the United States, still using the monkey, toilet seat, washboard, and tambourine as standard fare, along with anything else he can find to make people laugh.

Harry Jarkey
"Over at the Casino, comic Harry Jarkey was a fixture and when he no longer played there, it died. He was assisted by a few good men—musicians Dick Jessup and Al Smith, to name a couple. . . ." (Dick Hardy, *Bay City Times*)

In 1935, Harry Jarkey (1913–present) became the master of ceremonies at the Wenona Beach Casino, a position he held for the next 25 years. His 45-minute floor show (three to four times per day) mixed humor with his guitar and a long-barreled "herald" trumpet.

Mildred and Art Schiell
Art Schiell, a beauty salon owner, also ran a small recording studio from his home at 405 Raymond Street in Bay City from 1956 to 1969. "We record Everything" was the motto on his business card. In 1966, Schiell recorded "96 Tears" for Question Mark and The Mysterians, a young Mexican-American band from the area. The song became a national number one hit that year. (Courtesy of Geraldine Schiell.)

The Burdons, c. 1982
"The Burdons (founded 1981) were the first area rock band to embrace the D.I.Y. (do it yourself) ethic that emerged across the U.S. in the late 70s and early 80s, and the first to be presented a key to Bay City. Their self-titled debut album, *The Burdons*, was comprised of original songs that combined 60s pop and new wave energy, and it was released on the band's own record label." (Gary "Dr. J" Johnson, Michigan Rock Legends Hall of Fame)
From left to right are Paul Schultz, Scott Causley, Jim Davenport, and Dave Davenport. The band is still together, with one personnel change: Bob Charlebois has replaced Dave Davenport. (Courtesy of the Burdons.)

Jerry Marcet on Stage at Bemo's, 2005
Jerry Marcet (1953–2011) was a bass and guitar player and veteran of many bands in the area music scene for over 40 years. At his funeral, friend Dan Mazur told of Marcet's knack for learning to play just about any type of instrument, though he was an extremely humble individual. A veteran driver for FedEx Corporation, Marcet was playing in two Bay City bands, The Toyz and The Last, at the time of his unexpected death. (Courtesy of Dan Tomczak.)

Maestro Leo Najar, 2011

Leo Najar certainly had one of those larger-than-life personas. He knew how to make an entrance, how to "play it up," and would wear his enthusiasm on his sleeve—it was always infectious. At his memorial service, his stepdaughter Kathryn talked of his alter-ego, "Concert Leo," who knew how to play the part of the maestro—a certain arrogance, a hint of pompousness that goes along with the title. Many performers who played for him recall seeing this alter-ego appear in time to pull a show together almost out of thin air, entertain and dazzle the audience, and make every performer on the stage want to do their best, while eliciting a "better than their best" performance. It was said more than once that Leo "made me a better player." That "thin air" was actually many sleepless nights spent by Najar writing score after score to fit his vision for that particular show. For the Bijou Orchestra's Fall 2010 performance of "10,000 Dreams," he took the score for the theme from *Star Wars*, which was written for a large orchestra, and successfully rewrote it for the 13-piece Bijou. Maestro Najar (1953–2011) was originally from Grand Rapids and played the violin in his youth. He received his BA and MA in performance at the University of Michigan School Of Music. He taught at several schools of music, including University of Michigan, Interlochen Summer Arts Camp, and Blue Lakes Fine Arts Camp. In addition, he was the music director of the Saginaw Bay Symphony Orchestra from 1980 to 2003, and had previously held leadership positions in orchestras on three continents. Najar came to Bay City in 2003 and started the Bijou Orchestra, a small theater-style orchestra that perfectly complemented the historic State Theatre in Bay City, which the Bijou made their home for eight seasons. He was also the music director of the Bay Concert Band and the director of music at the First Presbyterian Church, near where he lived with his wife, Regina Turner, before his unexpected death in May of 2011. (Courtesy of Andrew Rogers.)

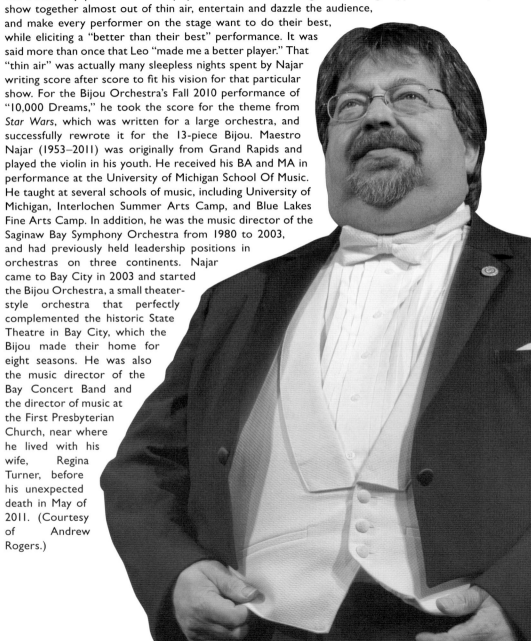

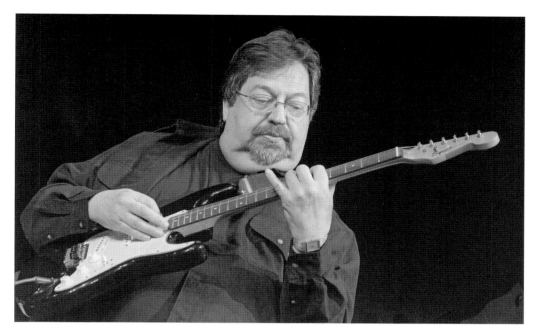

Leo Najar, 2011
A frustrated Leo Najar once quipped, "I just want to play guitar in a rock and roll band." During the latter seasons of the Bijou Orchestra, Najar started introducing some contemporary themes and rock and roll actually appeared in more than one concert, including the entire second half of "Made in Michigan" (April of 2011), Najar's last concert before his death, in which the maestro did get his chance to play guitar with a "rock and roll band." (Courtesy of Andrew Rogers.)

The Bijou Orchestra, 2004
The Bijou Orchestra in 2004 featured (left to right) Irina Tinkhonova, Derek Lockhart, Kelly McDermott, John Hill, artistic director Leo Najar (seated), Richard Illman, Susan Friedman (seated), Vickie Bowden, Jean Posekany, John Upton, Zeljko (Bill) Milicevic, Catherine McMichael, Toni Amiano, and Les Nicholas. In addition, Maestro Najar would supplement the lineup with local and national talent, including crowd favorites Rob Clark, Bob Bloenk, and Andy Rogers. (Courtesy of Andrew Rogers.)

Members of Bay City Players, 1961–1962 Season

The woman in the middle is Thelma Johnson. The woman on the right is Cabbie Nolan. Standing in the back is Jim Graham. Johnson, Nolan, and Graham were very active participants at Bay City Players (a volunteer-based community theater) on stage and backstage. All three served numerous times on the board of directors. When Players established the Dorothy and Ken Arnett Distinguished Volunteer Award in order to recognize outstanding volunteers, their names were three of the first group of names to be recorded. Thelma was married to Ed Johnson, who owned Washington Theatre, Colonial Theatre, and Pines Theatre. They owned Pines Theatre when it was sold to Bay City Players to become their current home at 1214 Columbus Avenue. The Bay City Players, founded as the Bay City Art Club in 1917, has the distinction of being the oldest continuously operating community theater in Michigan.

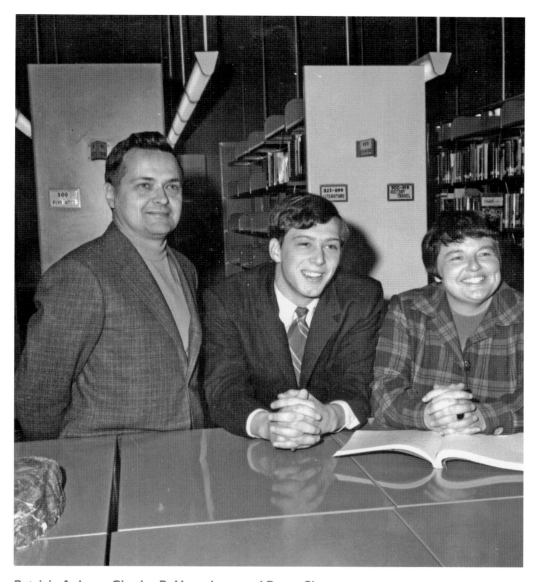

Patricia Ankney, Charles B. Humphrey, and Roger Simon
From right to left Patricia Ankney, director; Charles B. Humphrey II, assistant director; and Roger Simon, set designer pose before an early production c. 1960. "Miss Pat" Ankney (1933–2009) taught music and directed choirs for 42 years in the Essexville Schools and several colleges, producing 69 musicals, 76 concerts, and many variety shows. Garber High School's auditorium was named in her honor in 1996. Former colleague Leeds Bird described her as "a dynamic influence in the Essexville-Hampton School District. She was devoted to making the school district outstanding and worked constantly toward that goal. Beloved by a great many students, Pat established her reputation through her direction and staging of Broadway musicals in the community. Beginning at a time when very few musicals were produced in Bay County high schools, Pat selected shows of outstanding quality to showcase her students and her school: Garber High School. Pat's abilities to please audiences and incorporate up-scale elements into her productions are still reflected today in the quality of musicals performed by area high schools."

Marguerita P. "Rita" Greve
Rita Greve (1915–2010) is best known for her bronze and stone sculptures that have "mother and child" and wildlife themes. The versatile artist also worked in paint, ceramics, pewter, jewelry, photography, and poetry over her long career. Her work, a favorite among collectors, garnered commissions for pieces to be used in local businesses or given as awards; among them the YWCA's Princess Wenonah Award and the Chamber of Commerce's New Century Recognition Award. (Courtesy of Guy Greve.)

Irene Warsaw
A 1925 graduate of Bay City Central High School, Miss Warsaw (1908–2005) became a nationally recognized poet, with work published in magazines and papers throughout the country, and received numerous awards for her work. *A Word in Edgewise* (1964) and *Warily We Roll Along* (1979) were both compendiums of her work that included many insightful poems including:

REAL GONE

My own brand of name-dropping
Never gets brash—
Names drop from my memory
Quick as a flash.

CHAPTER SIX

Sports Notables

Think about traveling around the world in a duffle bag for 5 years for a chance to run for 15 sec to compete in the games. The whole thing was for 15 seconds of pushing and the outcome was the first medal in decades in the bobsled. Words that come to mind are . . . completely focused on a single goal for 5 years. Perseverance for sure. Bay City should be proud to have been represented in the Olympic Games by a hometown boy. Bay City was represented well.

Dr. Eric Maillette's reflection about friend, colleague, and Olympic champion Doug Sharp sums up the sacrifice that is required to become one of the best of the best. Including Doug Sharp, Bay City is fortunate to have welcomed three Olympic champions back home. Speed skaters Terry McDermott and Alex "Izzy" Izykowski were also awarded medals for their Olympic moments. Several stand-out professional athletes have also called Bay City home, including NFL player "Stinky" Hewitt, boxer "Kid" Levigne, and Boston Beaneaters' pitcher John Clarkson. The hometown rivalry of Bay City Central and T.L. Handy high schools produced some legendary coaches like Elmer Engel and Hi Becker. Though he could be lauded as a Legendary Local for more than a few of his accomplishments, business leader Art Dore is most closely associated with the amateur boxing world and the Toughman contests that he turned into a major athletic competition that launched the careers of more than one participant. The Bay County Sports Hall of Fame also preserves the stories of these and many other Bay County sports notables.

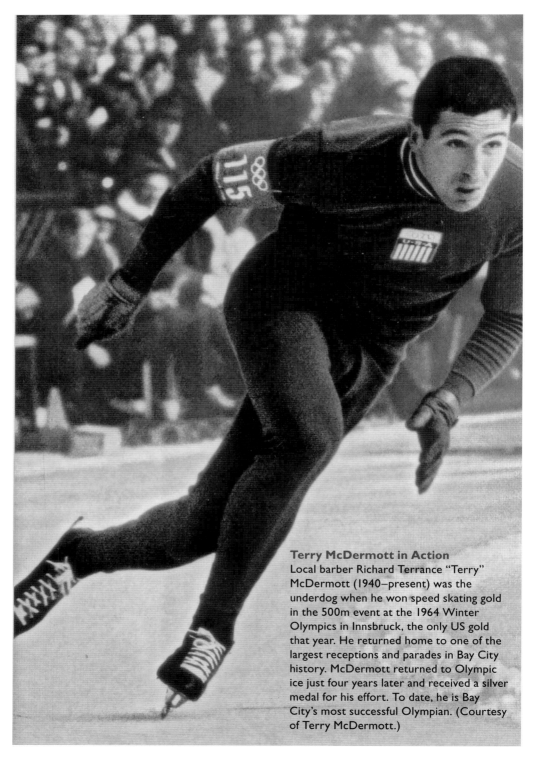

Terry McDermott in Action
Local barber Richard Terrance "Terry" McDermott (1940–present) was the underdog when he won speed skating gold in the 500m event at the 1964 Winter Olympics in Innsbruck, the only US gold that year. He returned home to one of the largest receptions and parades in Bay City history. McDermott returned to Olympic ice just four years later and received a silver medal for his effort. To date, he is Bay City's most successful Olympian. (Courtesy of Terry McDermott.)

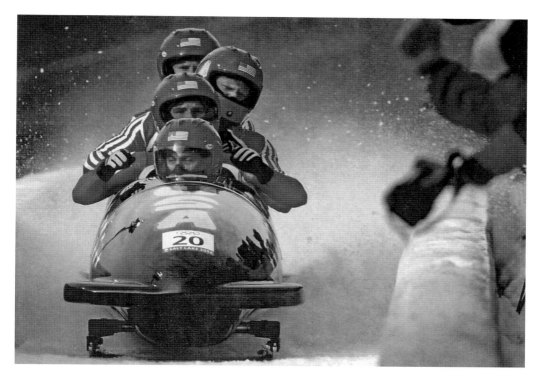

Doug Sharp at the 2002 Olympics
Years of training for 15 seconds and a shot at an Olympic medal was a goal that Sharp, third from front, was willing to let drive him toward success. A former standout in pole vault and football at John Glenn High School, Sharp was no stranger to competition. At the 2002 Olympic Winter Games in Salt Lake City, Sharp and his four-man bobsled team pushed and piloted the USA II sled to a bronze medal, even though they were considered a longshot. (Courtesy of Dr. Doug Sharp.)

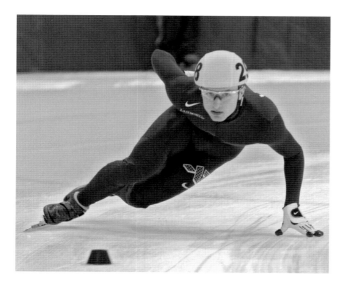

Alex "Izzy" Izykowski in Turin in 2006
Izykowski (1984–present) started short-track speed skating in 2005 and quickly posted impressive results. Encouraged by his father Al, president of the Bay County Speed Skating Club, "Izzy" trained with the goal of making the Olympics, which he achieved in 2006. In Turin, Italy, he placed fifth in the semifinals of the 1500m event, which earned him a place on the 5000m relay team. He and teammates J.P. Kepka, Rusty Thomas, and Apolo Ohno were awarded the bronze medal for their third place finish. (Courtesy of Jerry Search.)

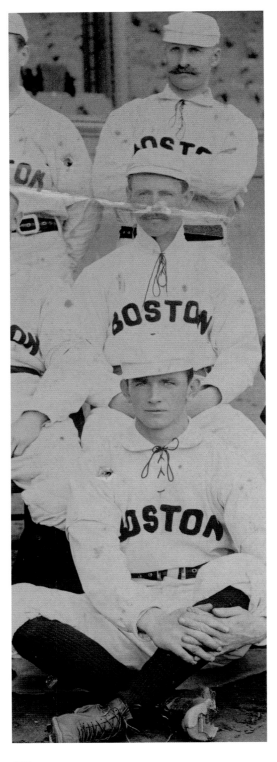

John Gibson Clarkson, 1891 Boston Beaneaters Photograph

One of Bay City's best-known baseball standouts, John Clarkson (middle, 1861–1909) played during the early years of the professional leagues. He was born in Massachusetts and found his way first to Saginaw and then to Bay City. He originally started as a center fielder for the Saginaw team in the Northwestern League and his pitching skills ultimately propelled him to the major leagues. Historian Augustus Gansser wrote of Clarkson in 1905, "One of Bay City's really famous citizens is John G. Clarkson, known all over the world as the peer of baseball twirlers, 1880-95, who played here in 1883-85, then for years was with Chicago, until sold for $10,000 to the world's champion team at Boston. He is still active promoting the National game locally." The right-handed pitcher first played for the Worcester Ruby Legs in 1882, then went to the Chicago White Stockings (later known as the Cubs) from 1884 to 1887, next it was the Boston Beaneaters from 1888 to 1892, and finally the Cleveland Spiders from 1892 to 1894. The Boston Beaneaters were the National League champions in 1891, 1892, and 1893. The franchise went through several name and hometown changes in subsequent years and they eventually became the Boston, Milwaukee, and finally the Atlanta Braves. During the 1892 season, Clarkson's pitching performance dropped sharply (possibly due to injury) and he was traded to the Cleveland team. Clarkson retired at the end of the 1894 season and moved back to Bay City. His career pitching statistics were very remarkable; of 531 games recorded, he won 328 and lost only 179. He was inducted into the Baseball Hall of Fame in 1963. When Clarkson moved back to Bay City, he opened John G. Clarkson & Company, cigar manufacturers. In 1895, he organized a local baseball team that likely played on a makeshift home field at the fairgrounds. In 1909, Bay City posthumously honored Clarkson with the dedication of Clarkson Park on May 15. This new baseball park was located south of Center Avenue and east of Livingston Street (near the city limits) and was built as the home field of the newly formed Bay City Cardinals. Clarkson, plagued by ill health the preceding few years, had died three months earlier of pneumonia.

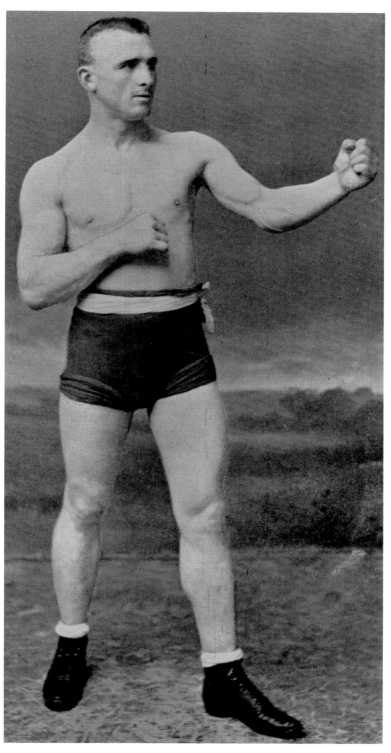

George "Kid" Lavigne, c. 1893
Kid Lavigne (1869–1928), born on the west side, became a professional boxer in his teens and fought with both bare hands and gloves. The International Boxing Hall of Fame inductee (1998) fought his way to a lightweight championship on June 1, 1896, a title he successfully defended six times until 1899. The southpaw boxer was arrested in 1894 for the death of an opponent during a match; he was later found innocent.

Bill Hewitt
After playing "average" football for Bay City Central and University of Michigan, William Ernest "Bill" Hewitt (1909–1947) became a standout on the football field in the National Football League with the Chicago Bears (1932–1936) and Philadelphia Eagles (1937–1939). He also played with the 1943 Phil-Pitt Steagles. "Stinky Hewitt" was known for the "Stinky Special," as "the offside kid," and for his refusal to wear a helmet. He died in a car crash in 1937 and was inducted into the Pro Football Hall of Fame in 1971. Hewitt is pictured left center in the front row of this 1927 Central Football team photograph.

1961 Handy High Varsity Football Team (ABOVE RIGHT)
Hi Becker is pictured in the center of the back row.

Elmer Engel (RIGHT)
Engel played football with some of the historic greats in the sport at the University of Illinois before he started his coaching career. In 1950, Engel accepted a position at Bay City Central and set about to turn the team's record around as Central had lost the previous 27 games. His first year coaching produced a 3-6 record and in his next 23 years he built that record to 165 wins with only 34 losses and 8 ties. Engel retired in 1973 as one of the most successful coaches in Michigan prep history, winning four state championships in eight years. In 1961, crosstown rival Handy High (now a middle school) under coach Hi Becker defeated Central 25–20 in the first victory over their rival in 10 years. Becker earned the Prep Coach of the Year title for the Class A state championship with an 8-0 season that year.

ELMER ENGEL

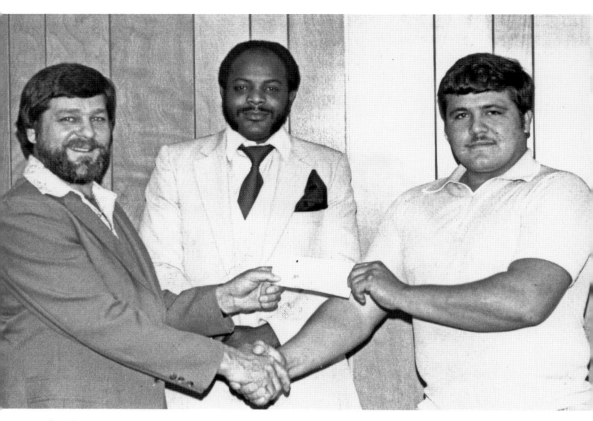

Art Dore, Roosevelt McKinley, and Dan Hiltz
Successful demolition contractor and former boxer Arthur P. Dore (1936–present) started the "Toughman" contest in 1979 to give amateur fighters a chance to compete. Dore and a partner rented the T.L. Handy gymnasium and put on the first event. Dan Hiltz, of Bay City, billed as "Twenty Grand Dan," won that amount as the runner-up in the state final contest held in Pontiac. By 2009, contests under the Toughman name had been staged throughout the United States and reportedly over 100,000 had participated. The event, immortalized in the 1984 movie *Tough Enough*, has launched the careers of many fighters. Dore, who worked for many years in the demolition business, currently has many local ventures including the Bay City Country Club and several restaurants. Dore, McKinley, and Hiltz are pictured after the Toughman Contest finals in 1979.

CHAPTER SEVEN

Community Figures

The marvelous richness of human experience would lose something of rewarding joy if there were no limitations to overcome. The hilltop hour would not be half so wonderful if there were no dark valleys to traverse. (Helen Keller)

There have been many Legendary Locals throughout Bay City's history who saw a need, an opportunity, or an injustice that needed action. For some, it became a life's calling or a profession; for others, it was an avocation or small chapter in their lives. May Stocking Knaggs petitioned for women's suffrage. Educators Odeal Sharp, Mary and Helen MacGregor, Richard Bendall, Louis Doll, and Patricia Drury devoted their lives to imparting wisdom on generations of local students at all levels from elementary school to college. Rabbi Josef Kratzenstein influenced many in the community from his teachings at Temple Israel. Marian Flora Spore Bush, an early dentist, left her practice for a life that was defined by her art and humanitarianism. Juanita Isaac and other Bay County Health Department nurses administered the Salk polio trials, a local chapter in one of the greatest medical discoveries of the 20th century. Gathering, preservation, and celebration of the community's history fell on the shoulders of many, including Maude Greenman, Cathy Baker, and the 1965 City Centennial Committee. The Bay City Woman's Club and Eastern Michigan Tourist Association (led by Thomas Frank Marston) both sought to influence and promote the positive within Bay City. After helping to build the Mackinac Bridge, Gen. Richard DeMara settled in Bay City to a life that was shaped by his service to the community. Leo and Betty Jylha moved to Bay City to accept positions at local radio station WBCM; their son Eric became the second family generation to have a long career in the media profession. Jeanette Lempke Sovereign and Henry Dora both became well known as early pioneers in the aviation field and helped influence the development of James Clements Airport. After a long and illustrious career as president of Delta College, Don Carlyon played a leadership role in rescuing the Bay County Library System from the devastation of a failed millage.

May Stocking Knaggs with Granddaughter Helen, c. 1907
Knaggs (1847–1917) had enough of an impact on Bay City and the state of Michigan to be inducted into the Michigan Women's Hall of Fame in 2002. Excerpts from the nomination form written by Edith "Dee Dee" Wacksman sum up Knaggs' historical contributions. "May Stocking Knaggs was a remarkable woman for her time, or any time. She worked, tirelessly in Michigan as a spokesperson for woman suffrage and was often in communication with national suffrage leader Susan B. Anthony. May was a featured speaker between 1887 and 1900 at suffrage meetings in Saginaw, Bay City, Grand Rapids, Ann Arbor, Detroit, and Pontiac. In May 1887 she addressed a joint committee of the senate judiciary committee and house promoting a bill granting municipal suffrage to women, as reported in the May 6, 1887 *Bay City Tribune*. . . . In 1894, May and Susan B. Anthony traveled New York state making sixty speeches promoting woman suffrage. In June 1896 and 1899 May spoke at the national suffrage conventions. May served as president of the Michigan Equal Suffrage Association from May 1895 to May 1899. May exchanged ideas by mail with suffrage leader Clara Arthur from 1907–1910. May Knaggs was appointed by Governor Bliss to the board of the Home of industry for Discharged Prisoners located in Detroit. May also served as a guardian for the Michigan Industrial Home for Girls in Adrian. May and another Bay City woman were the first women elected to Bay City Board of Education in 1887. . . . May was probably responsible for bringing Susan B. Anthony to lecture in Bay City in March 1893. May and her husband, John, also raised four children. . . . May Knaggs encouraged men and women to exercise their intelligence and abilities. May Knaggs opened doors for women in her community in the area of elected office and journalism."

Mary and Helen MacGregor

Sisters Helen (center right, 1858–1948) and Mary (center left, 1860–1955) MacGregor started teaching in the late 1870s. A plaque dedicating MacGregor Elementary school reads, "This school is affectionately dedicated to Helen and Mary MacGregor who, in the highest tradition of their calling, guided boys and girls in the American way of life, inspired teachers with a sense of their great responsibility, and gave devoted service to the community." Together they gave 109 years of service. They are pictured at a reception in their honor around 1944.

Odeal LeVasseur Sharp with Members of the Cloverlettes, c. 1965
Sharp (kneeling at left, 1912–present) was a student and later a teacher in local one-room schoolhouses. She also taught physical education through music and dance at local parochial schools from 1956 to 1963. She mentored many students over the years and was instrumental in founding the Essexville-Hampton 4-H Cloverlettes, a Scottish pipe band for students from 1956 to 1970. Sharp also authored several books on local topics, including *Bay County Ghost Towns and Place Names* and *Country Schools of Bay County, Michigan 1838–1970*.

Richard "Dick" DeMara on the Mackinaw Bridge During Construction, c. 1956
Balancing on a narrow catwalk stories above Lakes Huron and Michigan over the Straits of Mackinac would likely make most people very uneasy. DeMara (1929–present) said that in his 31 years as an iron worker, he is most proud of the time he spent high above the water at the Straits inspecting work and spinning the large cables that hold up the roadway of the Mackinac Bridge, Michigan's greatest engineering marvel and the world's third longest suspension bridge. The five-mile-long bridge was started in 1954 and opened to traffic on November 1, 1957, just in time for that year's deer season. DeMara, a Cheboygan native, worked the bridge crews from 1956 to 1958, for $3.50 an hour, good wages for that era and enough to persuade 3,500 construction workers that the risk of the working environment was worth it. Fatalities on the job were a reality, and during his time there DeMara witnessed two of the five total deaths that took place building the bridge. He was also able to witness the first unofficial automobile trip across the bridge. DeMara also spent 39 years in the National Guard, which he joined the day after his 18th birthday. He retired in 1986 having achieved the rank of one-star general. One of his more memorable deployments was to Detroit during the 1967 riots. In 1963, he was assigned as a maintenance officer to the staff of the 3rd Battalion 246 Armored, Bay City, Michigan. His illustrious career with the National Guard led to many assignments, trips overseas, and numerous decorations and awards. A Bay City area resident, he spent much of his career at the Bay City Armory on Washington Avenue, and when the Guard moved to new quarters, he was instrumental (along with local politicians J. Robert Traxler, Jim Barcia, and Tom Hickner) in acquiring the building for the Bay County Historical Society's new museum. He has been an ardent supporter of many local organizations, including the Historical Society and American Legion Post 18. (Courtesy the DeMara family.)

Maude Greenman
George E. Butterfield wrote in 1957, "The Bay County Museum is rated very high among county museums in the state, and for the last forty years it has been kept in excellent condition by the devoted work of the curators, Mr. and Mrs. Allen T. Greenman. The Museum provides an authentic picture of the history of Bay County and a glimpse into the beginnings of the nation as a whole." Curator Maude Greenman and student volunteer Don Comtois are pictured in the County Building Museum Rooms.

The Bay City Woman's Club
The Bay City Woman's Club was organized in 1892 to promote and further education and community and social improvements. In 1906, their Forestry Committee planted elms and gingko trees in all area schoolyards in memory of Martha Snyder Root, a founder of the club. The club was instrumental in many projects throughout Bay City in later years. Here the club plants a gingko tree at Fremont School in 1906.

111

Salk Polio Field Trials, 1954

The fear of contracting polio was an ever present worry on the minds of local residents. The disease could kill, and even those who survived it had their lives changed forever. A vaccine was developed by Dr. Jonas Salk in the early 1950s. To test its effectiveness, children across the nation, including around 2,500 in Bay County, were to receive shots, with half of them getting the real vaccine. In Bay County, the Salk polio field trials were coordinated by Dr. C.E. Reddick, director of the city-county health department. Seventeen city and county nurses helped with the trials and were later honored by Dr. Reddick. From left to right are Marie Mrozinski, Juanita Isaac, Pauline Duffy, Bernadine Benson, Marguerite Culberson, Jane Zess, Anna Ryan, Ethel O'Connor, and Mary Ellen Redmond (public nursing service director).

Thomas Frank Marston (RIGHT)

Marston (1869–1942), son of Hon. Isaac Marston, was the well-known manager of the Eastern Michigan Tourist Association (EMTA) and was considered a leader in the local community. The EMTA, formed in 1924, consisted of 31 counties who collaborated in advertising for tourists. He also helped organize the Bay City Sanitary Milk Company in 1902. After his death, a room in the Wenonah Hotel was named in his honor. T.F. Marston is pictured outside of the EMTA log office with marketing "material."

Leo and Bette Jylha (LEFT)

Leo Jylha (1913–1992) learned radio engineering during college in Port Arthur, Texas. He took a position at WJIM in 1941 and entered the Navy when the war broke out, returning to WJIM after the war. Bette (1923–present) also worked at WJIM from 1943 to 1946. She was a pioneer on-air host, doing various programs, including the "Stork Reporter," and engineered radio broadcasts like the all-women big bands that were popular during the war. They knew each other pre-war but didn't date until after; they later married. The Jylhas moved to Battle Creek in 1947 when Leo took a job at WBCK, and they had son Eric in 1949. WBCK's sister station was WBCM in Bay City, where Leo went to become general manager in 1956 until he retired in 1973. Bette also worked at WBCM as a copywriter and performed vacation fill-in duties, and later went on to work in advertising at Parker, Willox, Fairchild and Campbell in Saginaw among other agencies. She retired in 1980. (Both courtesy of Eric Jylha.)

Eric Jylha at WSGW, 1982

Jylha (1949–present) followed his parents to a career in broadcasting. He attended Delta College and Michigan State University and started working in radio and at WUCM, as the Delta College TV station was called in 1967. He worked as a disk jockey, and then a news reporter at WBCM, WXOX, WGER, and WSGW. After three years away, Jylha became a TV reporter and weekend anchor at WNEM TV-5 in 1986, until switching to weather in 1992. He is also well known "off the air" as a host and emcee at many local events. (Courtesy of Eric Jylha.)

Donald J. Carlyon at Delta College, c. 1967
"Don Carlyon has always cared deeply about libraries and learning. Fortunately for Bay County citizens, at a critical time when our library system lost voter support and was in jeopardy of closing, Don stepped forward to restore community trust and favor. His voice of reason, personable leadership skills, unwavering optimism, and gentle fence-mending efforts brought the library back from turmoil to stability. Today's strong, vibrant libraries stand in tribute to Don Carlyon." (Linda Heemstra, retired Bay County Library System director)

Don Carlyon (1925–present) was no stranger to leadership when he became the public face of the Bay County Public Library System, which was in serious jeopardy after voter dissatisfaction led to two failed operating millage attempts in 2006. Even with a brand new main branch library, the system was forced to close satellite branches and lay off 120 staff, resulting in significantly reduced services for 2007. With morale at an all-time low, Carlyon, in his first year as a newly elected library trustee, was unanimously elected chair of the board. Carlyon set the tone for what it would take to regain the support of Bay County voters. "Those who benefit from that committed service cover all ranges—from the little ones who are just barely old enough to understand to appreciate what the library has to offer. . . to those of us who have been retired for some time. We cannot emphasize strongly enough we are a service body—not a political one." The new operating millage passed in November of 2007 and the library system restored services. Residents knew Carlyon well before his tenure with the library board, as he was the president of Delta College from 1967 to 1992. A native of Nebraska, Carlyon and his wife Betty came to a brand-new Delta in 1964, planning to stay only a few years. The couple, now married for over 70 years, made the area their adopted home. Carlyon told the Rotary Club a few months ago that even though his tenure far exceeded the average of five to six years, he never really stayed in the same college for all of that time—Delta was changing so much during those years that every few years it would re-invent itself. That was what kept him interested, engaged, and involved.

Dr. Louis Doll, Marvin Tong, and Henry Rexer (Right to Left)
Doll (1911–2001) came to Bay City in 1953 to teach history at Bay City Junior College and later Delta College, retiring in 1977 after a long career. During World War II, he was assigned to the Army's Japanese Language School, which led to a life-long fascination with Japanese culture and several visits to postwar Japan, where he helped modernize a university library and was given an honorary doctorate for his work. Doll (right) is standing outside of the Museum of the Great Lakes on Center Avenue, c. 1970; he spent many hours as a volunteer, board member, and past President of the Bay County Historical Society.

Patricia Drury, 2001
Drury came to Bay City to teach at Bay City Junior College in 1959 and then moved to the newly opened Delta College until retiring in 1990. A history professor, she is best known for her western civilization courses. She has spent retirement transcribing the diaries of Linwood pioneer Myra Parsons, and researching the history of the local legal system, for which she received the Bay County Bar Association's prestigious Liberty Bell Award in 2009.

Rabbi Josef J. Kratzenstein

Kratzenstein (1904–1990) was a native of post–World War I Germany. Educated in Germany and Switzerland, he was in (neutral) Switzerland when Jewish emigration in Germany closed just prior to World War II, and he missed out on a chance to go to Leipzig, Germany, to take a position: a move that likely saved his life. His family back in Germany was in a small village that was raided by the Nazis and his 70-year-old mother was taken to the concentration camps, from which she did not return. In Geneva, Rabbi Kratzenstein helped in the rescue and education of orphaned Jewish children, even taking some of the neediest into his own home. Highly educated, with a PhD from the University of Zurich in 1931, and ordination by the Rabbinical Seminary of Berlin in 1936, Kratzenstein spent most of his life in leadership and teaching positions, first in Europe and later in the United States, settling with his wife Rachael, in Bay City to lead Temple Abraham from 1949 to 1951. He returned to Bay City in 1962 to head the congregation at the newly built Temple Israel on Center Avenue, staying in the community the rest of his life. He was known widely and highly regarded for his philosophical leadership and humanitarian efforts. Patricia Drury, a friend and colleague, remembered the rabbi as, "…usually light and humorous. We learned to pay attention. Without warning he could pose a question, or ask for a repeat of what points he had been making." Leon Katzinger, local author and retired educator, grew up going to Temple Abraham and remembered "Rabbi K." as, "A big and powerful man, we dwelled on every word he said—we were in awe of him. He never talked about his family losses in Germany. He is the first Rabbi I remember, it was hard for him to be replaced and in his last years he was Rabbi Emeritus. He had a wonderful way of speaking and always had a point to take away—a very philosophical man." (Courtesy of Andrew Rogers.)

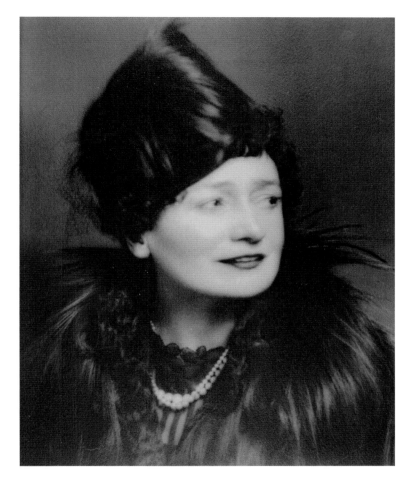

Flora Marian Spore Bush

Spore (1878–1946) graduated from the University of Michigan College of Dentistry in 1899 and in 1901 came back to her hometown to become Bay City's first female dentist. Her practice in Bay City was very progressive and included inlays, crowns, bridgework, and dental implants all done in her own lab. She suddenly retired from her practice in 1919 and went to Guam to start painting. The small fortune she earned from her practice afforded her the means to travel and she ended up settling in New York, where she continued her painting. Her work was highly regarded and would later be displayed in the most prestigious of art galleries in New York and even the Fine Arts Gallery of London. One reason her work received major publicity was because of her belief that her artwork was being guided by artists long dead. She was a firm believer in the afterlife and that the living could communicate with the dead. Press about her work appeared in both the professional press and the tabloids of the day; her work even solicited comments from master illusionist Harry Houdini. She also became known as the "Angel of Bowery" after she used her means and influence to start a soup kitchen in the depressed Bowery area of New York in 1927. She continued her charity work for years, even branching out to providing clothing, wheelchairs, and other medical necessities for the needy. In 1930, Marian Spore (she had earlier dropped the "Flora") married wealthy businessman Irving T. Bush and settled into a life split between social hostess and artist. After her death in New York, a large retrospective of her work was undertaken in the city in 1946, and most of her artwork (now owned by patrons and family members) has not been seen by the public since.

119

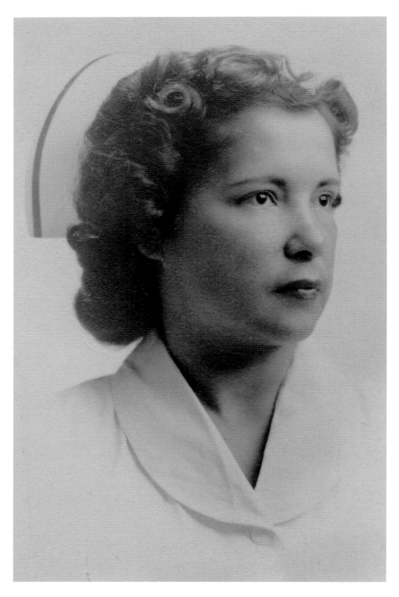

Juanita Isaac at graduation, 1946
Isaac (1917–1996), rose to the top of her class at the Mercy Hospital School of Nursing when, as an honor student, she was elected class president. Her family was of Chippewa descent and her brother was Chief Leonard Isaac of the Saginaw Chippewa Tribe. She turned her nursing training into a long career of 30 years with the Bay County Health Department as a nurse, even participating in the Salk polio trials for which she was honored. An advocate of her Native American heritage, she founded the Saginaw Valley Indian Association in 1972.

Vera Jeanette Lempke Sovereign (RIGHT)
Jeanette Lempke (1899–1966), came to Bay City from Indian River in 1925 to work for the Aladdin Company as an executive secretary for W.J. Sovereign, eventually working there for 30 years. She took some flying lessons from Henry Dora (and others) and gained her private pilot's license in 1930, with her commercial license following a few years later (only the third woman in the state to be so licensed). During her flying career, she placed well in several high-profile races and from 1947 to 1949 was elected the international president of 99, the international organization of women pilots founded by Amelia Earhart. Her years with that organization were served with distinction. She later married W.J. Sovereign in 1946. She served on the board of directors of the Rachel Sovereign Memorial Home and was a member of the General Hospital Auxiliary.

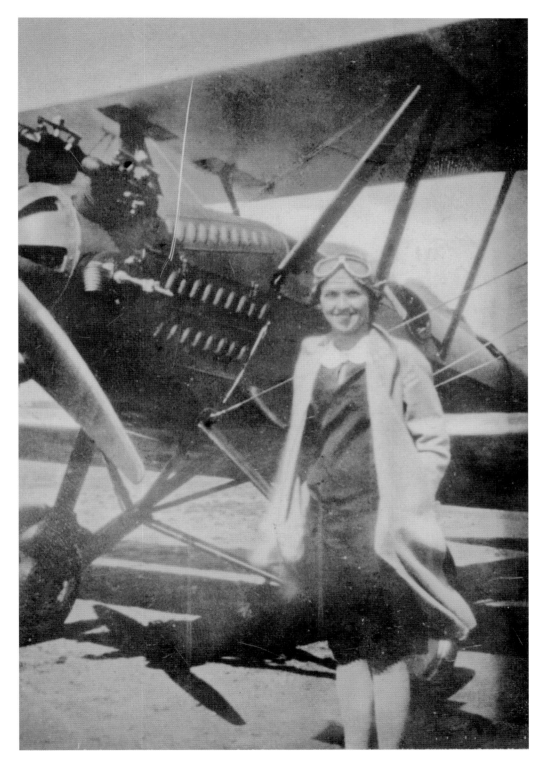

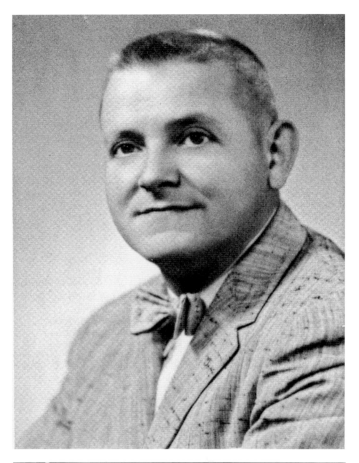

Richard Bendall, c. 1957
"Mr. Handy," Richard Bendall graduated from Bay City Central High School in 1935 and attended Bay City Junior College before graduating from Alma College in 1939. He taught briefly at T.L. Handy before entering the service for World War II in 1942. After the war, he returned to teaching at Handy in 1947. He retired in 1980 after 40 years with the Bay City public schools, most of it spent at T.L. Handy High School of which he was a tireless promoter.

Cathy Baker Receives an Award, c. 1975
Cathy Baker (Unknown–1986) was an amateur historian and author whose interest in local history helped her and husband Paul preserve a large collection of local history. "Her tireless efforts and intimate knowledge of historical source materials rivals or exceeds that of most professional historians," aystate library official lauded in the foreword to her 1975 book, *Shipbuilding on the Saginaw*. Her large collection was bequeathed to the Bay County Historical Society, where she had spent many hours as a volunteer.

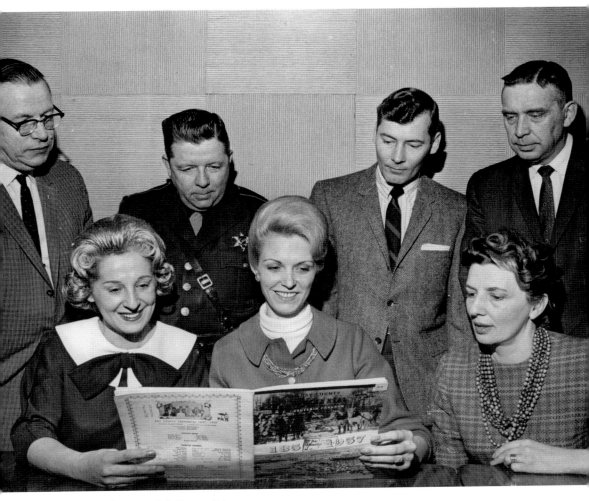

The Bay City Centennial Committee

Bay City mayor M. Monte Wray summed up what the 1965 Bay City Centennial festivities meant in his message of welcome "… Let us not only look back with fond memories of the days gone by, but let us set our sights on the future, resolved to direct our energies and talents to the end that Bay City shall continue to progress and go on to greater things." The festivities honoring 100 years placed an emphasis on both the past and future. The committee included well-known community leaders (seated left to right) Audrey Walker, Iona Jagelka, Margaret Bradfield (Red Cross director and community volunteer); (standing left to right) Les Arndt newspaper reporter and amateur historian), James Tanner (former mayor), M. Monte Wray (mayor of Bay City), and an unidentified member. The festivities included an ambitious production of "By These Waters," a pageant celebrating Bay City's past. Here the Bay City Centennial Committee reviews historical materials on February 21, 1964.

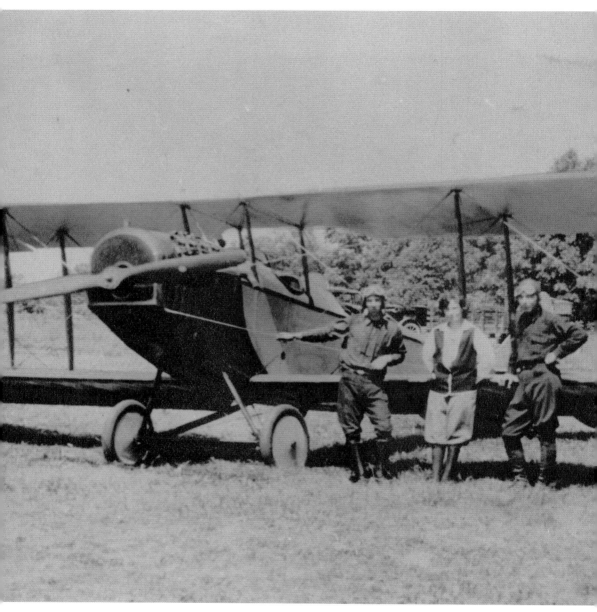

Henry "Hank" Dora (left) and Lillian Dora (middle) with "Jenny" airplane, c. 1922
Henry Dora (1893–1977), an accomplished mechanic and woodworker, started repairing Lionell DeRemer's planes and received flight instruction from the "early bird" in return. Dora was a constant tinkerer, into anything mechanical, boats and airplanes among his favorites. He purchased a war surplus "Jenny" airplane in 1922 and barnstormed throughout the region with his wife Lillian. Dora became the manager of James Clements Airport (dedicated on October 2, 1928) and supervised the building of the first airstrip. He held the position of airport manager until 1942 when he resigned. Dora managed the airport through its early growth from a small airstrip to a bustling hub for aviation and continued to keep busy in his post-airport days, even building a large steel yacht called the *Atomic*.

BIBLIOGRAPHY

Biographical Publishing Company. *Portrait and Biographical Record of Saginaw and Bay Counties.* Chicago: Biographical Publishing Company, 1892.

Bloomfield, Ron. *Maritime Bay County.* Charleston, SC: Arcadia Publishing, 2009.

Butterfield, George Ernest (ed). *Bay County Past and Present (Centennial Edition).* Bay City, MI: Bay City Board of Education, 1957.

Butterfield, George E. (ed). *Historic Michigan Volume III (Bay County).* Dayton, OH: National Historical Association, Inc., 1924.

Gansser, Augustus H. *History of Bay County, Michigan and Representative Citizens.* Chicago: Richmond and Arnold, 1905.

Honsowetz, Lois Kent (ed). *Pioneer Memoirs.* Bay City, MI: Bay County Historical Society, 1995.

H.R. Page and Company: *History of Bay County Michigan.* Chicago: H.R. Page and Company, 1883.

Katzinger, Leon. *Then and Now: Bay City.* Charleston, SC: Arcadia Publishing, 2004.

Kilar, Jeremy W. and Ron Bloomfield. *Bay City Logbook, An Illustrated History.* St. Louis, MO: G. Bradley Publishing, Inc., 1996.

Kilar, Jeremy W. *Michigan's Lumbertowns.* Detroit: Wayne State University Press, 1990.

Rogers, D. Laurence. *Paul Bunyon, How a Terrible Timber Feller Became a Legend.* Bay City, MI: Historical Press, 1993.

Memorial Society of Michigan, Inc. *In Memoriam, Founders and Makers of Michigan.* Detroit: S.J. Clarke Publishing Co, Inc., undated.

Pediment Publishing. *Through the Lens, A Visual History of Bay County.* The Pediment Group, 2008.

Rezner, Joan Totten Musinski (ed). *Women of Bay County.* Bay City, MI: Museum of the Great Lakes, 1980.

Wolicki, Dale, and The Bay County Historical Society. *The Historic Architecture of Bay City, Michigan.* Bay City, MI: Bay County Historical Society, 1998.

INDEX